Hewlett-Woodmere Public Library

The Dido Smith Fund

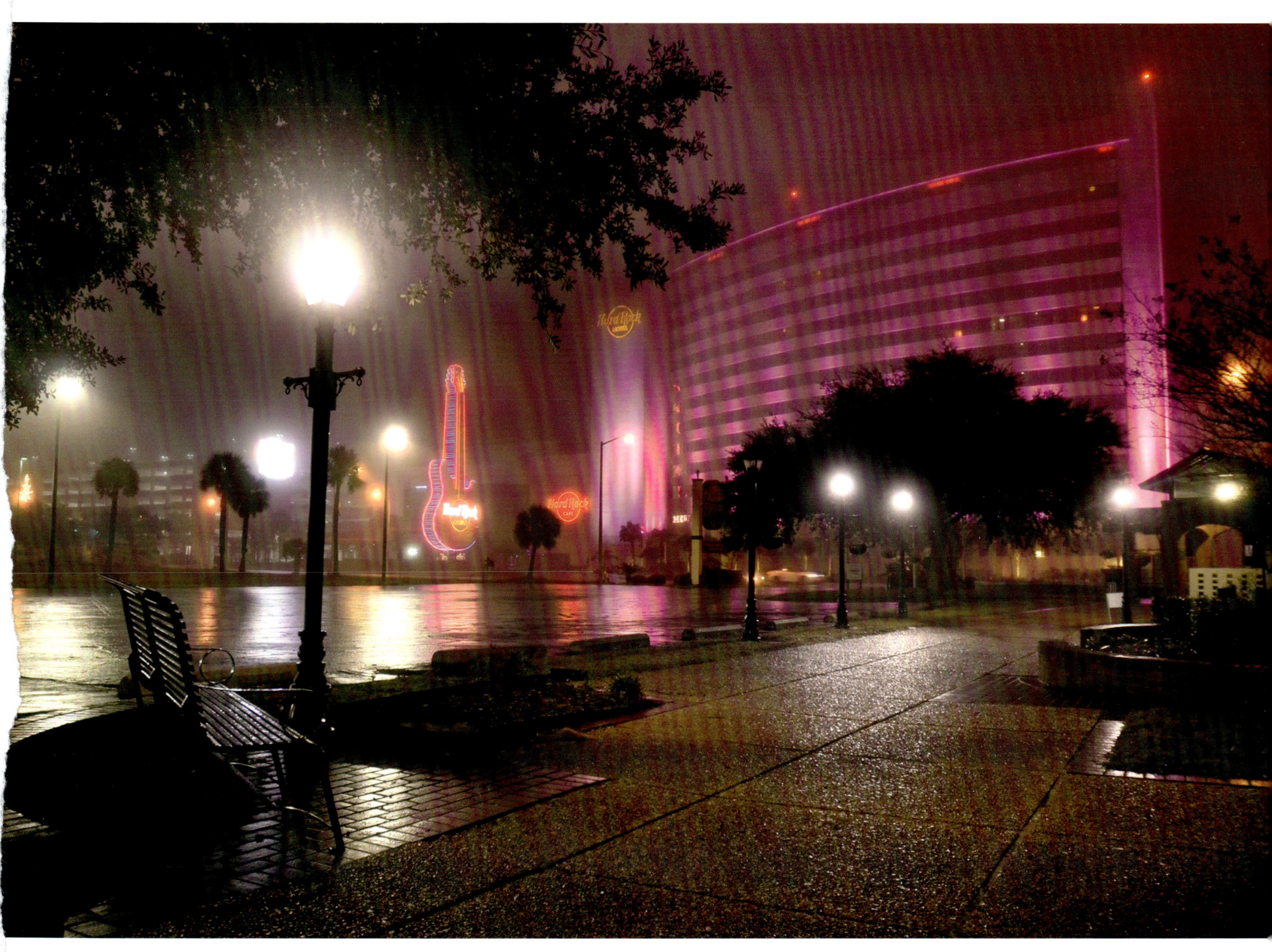

THE MISSISSIPPI GULF COAST

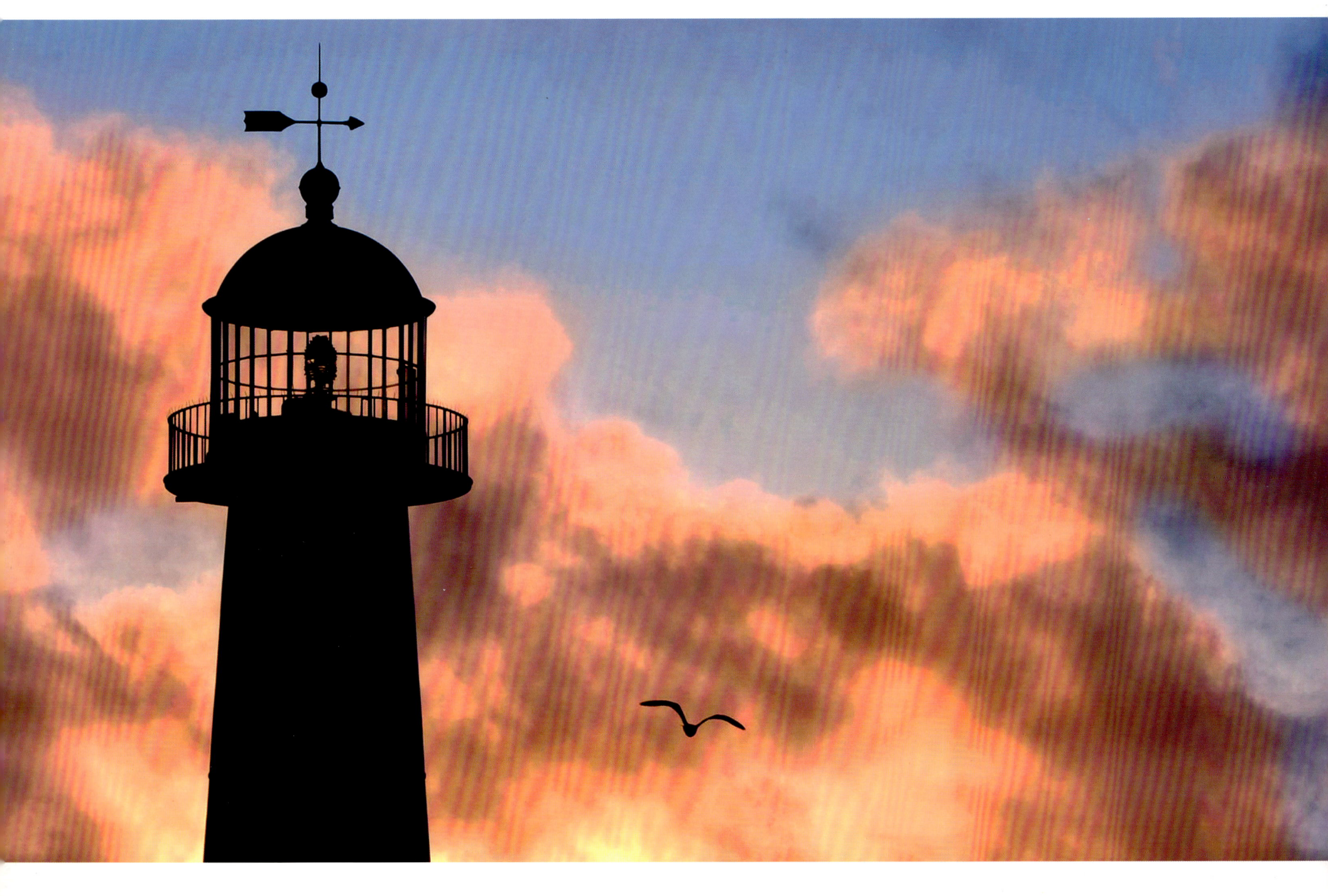

THE MISSISSIPPI GULF COAST

Timothy T. Isbell

University Press of Mississippi / Jackson

www.upress.state.ms.us

The University Press of Mississippi is a member
of the Association of University Presses.

Designed by Todd Lape

Copyright © 2018 by University Press of Mississippi
All rights reserved
Manufactured in China

First printing 2018

∞

Library of Congress Cataloging-in-Publication Data

Names: Isbell, Timothy T., author.
Title: The Mississippi Gulf Coast / Timothy T. Isbell.
Description: Jackson : University Press of Mississippi, [2018] | Includes bibliographical references and index. |
Identifiers: LCCN 2017058466 (print) | LCCN 2018000681 (ebook) | ISBN 9781496818980 (epub single) | ISBN 9781496818997 (epub institutional) | ISBN 9781496819000 (pdf single) | ISBN 9781496819017 (pdf institutional) | ISBN 9781496818973 (cloth : alk. paper)
Subjects: LCSH: Gulf Coast (Miss.)—History—20th century. | Gulf Coast (Miss.)—Pictorial works.
Classification: LCC F347.G9 (ebook) | LCC F347.G9 I83 2018 (print) | DDC 976.2—dc23
LC record available at https://lccn.loc.gov/2017058466

British Library Cataloging-in-Publication Data available

This book is dedicated to the two most important people in my life—my wife, Judy, and my son, Patrick. The support and understanding both of you give me while I'm immersed in another photo shoot or book project keeps me going.

This book is in memory of my late mother, Geraldine Isbell Kynerd, who died while I was working on this project. I'm sure she would have liked to see the finished product.

This book is in honor of the people of the Mississippi Gulf Coast. Through the good times, bad times, and the horrific Hurricane Katrina, I have never met a more resilient, quirky, and fun-loving people. I'm glad to say the Mississippi Gulf Coast is my home.

CONTENTS

Acknowledgments xi

Preface xiii

The Mississippi Gulf Coast 1

Coast Traditions 154

Bibliography 169

Index 171

BAY ST. LOUIS	PASS CHRISTIAN	LONG BEACH	GULFPORT	BILOXI	D'IBERVILLE	OCEAN SPRINGS	PASCAGOULA
24	42	56	64	84	122	126	140

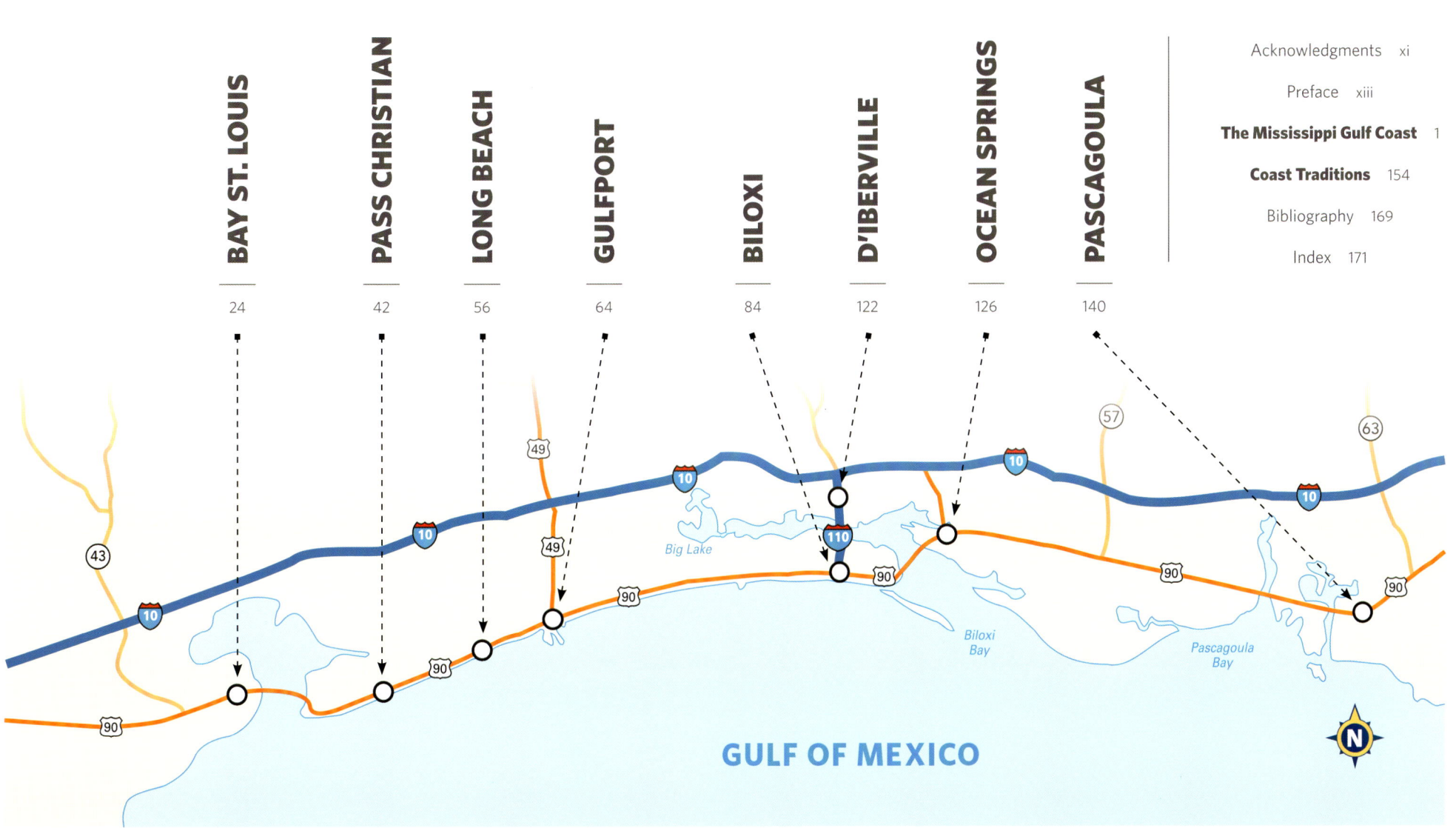

ACKNOWLEDGMENTS

Since 1984, the Mississippi Gulf Coast has been my home, a place to share with my wife, son, dear friends, and family. The area has given rise to my most profound joy as well as my deepest despair.

To describe my love for the Coast, I must steal a line from one of my favorite movies. In *Field of Dreams*, Moonlight Graham explains to Ray Kinsella the hold his hometown has on him: "This is my most special place in all the world . . . Once a place touches you like this, the wind never blows so cold again. You feel for it, like it was your child."

While all of my books are always a work of love, *The Mississippi Gulf Coast* has special meaning, as it was a therapeutic endeavor after the destruction from Hurricane Katrina. *The Mississippi Gulf Coast* is simply a book about home.

I am indebted for the help given to me by the staffs of the following libraries and museums: the University of Southern Mississippi; the State of Mississippi Department of Archives and History; and the libraries and genealogy collections at Biloxi, Gulfport, Pascagoula, and Bay St. Louis, Mississippi, as well as Mobile, Alabama. I am especially indebted to my friends at the University of Southern Mississippi Gulf Coast Library. That library has become my second home and primary resource as I research my latest books.

I thank my best friend, David Purdy. David is like a brother to me. We have been through thick and thin together. David used to work and live on the Mississippi Gulf Coast. He moved back to Iowa after Hurricane Katrina. We still keep in touch, but I miss his daily presence in my life.

Thanks go to Frances Lucas. She is a trusted friend of both my family and the University of Southern Mississippi Gulf Park campus. The campus where I do my book research would not exist without the renowned drive of Frances Lucas to rebuild after Hurricane Katrina.

I thank Patrick and Cris Simmons, who have been especially kind to my family for many years. I have listened to Patrick Simmons and the rest of the Doobie Brothers since I was a teenager. Their music has been with me through all walks of my life, including the time I spent working on this book.

I thank my Facebook friends, who have seen a few of these pictures over the years. I would post a few to get feedback on what they commented on or liked. Some of those comments helped me to pick certain pictures for the book.

I thank a group of people I refer to as the "Pennsylvania Nine." These people from Brookville, Pennsylvania, came to the Mississippi Gulf Coast to help those affected by Hurricane Katrina. They were truly heroes. They camped in my backyard at night

and helped Katrina victims by day. Their fellowship during those first weeks after the storm brought laughter back into our home. That was in short supply during the dark days after Katrina. Before heading back home, they cleared my backyard of ten downed trees. They will always be thought of with undying gratitude by my family. It is my hope they get this book and see the beauty of the place they helped rescue after Katrina.

Thanks go to Bill Jacobs of the *Brookhaven Daily Leader*. Bill gave me my start in the world of journalism. I am still proud to call myself a journalist. Much of what I learned as a journalist helped me to become an author.

I am indebted to the late Vernon Matthews, my favorite boss. Vernon gave me the confidence and the freedom to produce good work at the *Sun Herald*. Given his early tutorship, I have served as the eyes of the Mississippi Gulf Coast for more than thirty years. Thanks also go to Roland Weeks, Mike Tonos, and Stan Tiner, whom I respect and count as friends.

I am proud of my career at the *Sun Herald* and to be a member of the 2006 Pulitzer Prize–winning newsroom for our coverage of Hurricane Katrina.

I thank Craig Gill, Steve Yates, Todd Lape, Shane Gong, Emily Bandy, Camille Hale, and all the gang at University Press of Mississippi. This is my fourth book with University Press of Mississippi. I hope to have many more books made with this talented group of people.

I have always said that I'm a product of my parents and my teachers. Whether at home or at school, they have had an everlasting influence on my life. B. P. Williams, my history teacher at Provine High School, made history fun and visual. She pasted photos from *Time* and *Life* magazines on her classroom walls. Her future photojournalist student soaked up history from the books and from the photographs on her walls.

After the death of my father, my coaches became the primary male influences on my life. Many thanks go to Wayne Fields, my football and basketball coach at Hardy Jr. High. Even now, I still call him "Coach" on Facebook. Ray Holder, my soccer coach, and Ken Acton, Glen Davis, Rusty Windham, and Glen Slay, my football coaches at Provine High School, were also positive influences.

Gene Wiggins, Ed Wheeler, John Frair, and William "Doc" Scarborough were influential professors at the University of Southern Mississippi.

Frair and Wheeler were my photographic mentors and tormentors, always pushing me to do my best. Scarborough was my demanding History of the Old South professor who always made history fun and exams a challenge.

Dr. Wiggins was my Communications Law and Journalism professor. He was demanding but fair, tough yet funny, a respected professor and dear friend. Even after graduating from Southern Miss, I would see Dr. Wiggins at USM football games. We would talk and joke around, and he would always ask about my wife and son. Dr. Wiggins was family. My wife and I were saddened at his passing in 2013. Southern Miss doesn't seem like the same place without him and his sense of humor.

I would be remiss not to mention my fellow group of Southern Miss photojournalists. Just trying to keep up with this talented bunch keeps me sharp.

I would like to thank James Jones, Jeff Clark, and Laurene Callander for their friendship. Having such unwavering support from trusted friends keeps me grounded.

My parents, the late Wiley Travis Isbell and the late Geraldine Isbell Kynerd, were positive role models in my life. My father, a World War II veteran and lifelong serviceman, was a pillar of strength and reason. My mother, who died while I was putting the finishing touches on this book, possessed fire and drive, only wanting the best for her children.

As the baby of the family, I grew up under the shadow of my big sister. It took me a few years to grow out of that shadow, but I always appreciated her looking out for me. Thanks go to Cindy Kay Isbell Huerkamp. We hardly agree on politics or what news program to watch, but I know my big sister always has my back.

This book would not have been completed without the love and support of my wife, Judy, and son, Patrick. For more than thirty years, Judy has been my colleague, best friend, wife, editor, and confidant. She is a trusted and valuable teammate in all my book endeavors. She is my staunchest supporter and worst critic. The combination keeps me honest.

Patrick is starting his own life away from home. He has grown up to be a good young man. I probably don't say it enough, but I am proud of my son.

I also send thanks to my extended family in Mississippi, Alabama, Pennsylvania, New Jersey, and North Carolina.

Finally, I would like to thank the people of the Mississippi Gulf Coast. This book is a celebration of their indomitable Coast spirit. In the final scene of *Field of Dreams*, Ray Kinsella asks his father, "Is there a heaven?" His father replies, "Oh, yeah, it's the place where dreams come true."

In closing, I would like to thank God for placing me and my family on our little slice of "heaven." The Mississippi Gulf Coast is where our "dreams" came true. ∎

PREFACE

Sometimes I do get to places just when God's ready to have somebody click the shutter.
—ANSEL ADAMS

"The Coast"

As a Mississippi boy born and bred, my hometown was the capital city of Jackson. For my family, the Mississippi Gulf Coast was a place to visit and have fun. This area with the lighthouse, long white beaches, and seafood restaurants was our destination on numerous trips.

My sister and I did not refer to this area as Bay St. Louis, Pass Christian, Long Beach, Gulfport, Biloxi, or Ocean Springs. It was just simply "the Coast."

Many of my childhood memories occurred on the Mississippi Gulf Coast. We have home movies of me as a small child running along the beaches of Gulfport and Biloxi.

With my cousins from Alabama and Texas meeting us in Biloxi, we had a three-family vacation on the Coast. Memories include my Aunt Dot and my mother crawling under the arched bridge that separated the big pool from the kiddie pool at the Biloxi Holiday Inn.

We have home movies of our families at Six Gun Junction, where cowboys would conduct gun fights in a small Western town at the Biloxi-Gulfport line. Years later, I would spend a career of more than thirty years just north of Six Gun Junction.

Another trip to the Coast brings to mind the fury of storms that frequent the area. Our home movies show the Biloxi Lighthouse and tourist train against a dark cloud horizon as the first of the feeder bands of Hurricane Betsy made their way to the Coast.

Our last Betsy moment was eating at the Friendship House on DeBuys Road and watching Highway 90 flood from the wind and rain. I remember my father driving back to Jackson that night as I watched the streaks of lightning dance across the sky.

For a little boy with a vivid imagination, the Coast was always a place to be with family and experience all types of adventure.

Hurricane Camille

My next memory of the Coast was in 1969 when Hurricane Camille brought her fury and destruction to the area. From our home in Jackson, my family watched the continuing coverage of damage along the Coast.

Once again, we have home movies of that time. The movies weren't of destruction but of a caring nation attempting to help Coast residents. From our seats in the coliseum in Jackson, my mother filmed Bob Hope's *We Care* telethon to help victims of Hurricane Camille.

Although it seemed impossible that the Coast could ever rebuild after Camille, I became aware of the grit and determination of the people of the Coast. While it would take many years, the Coast would rise from the devastation.

I continued to visit the Coast throughout the years with family and high school and college friends.

The Coast . . . My Home

In the winter of 1983, I interviewed for a job at the *Gulfport/Biloxi Daily Herald*. I had graduated months before from the University of Southern Mississippi. In March 1984, I left my job at the *Brookhaven Daily Leader* to accept a job as photojournalist at the *South Mississippi Sun* and the *Daily Herald*—newspapers operating in the same building and sharing one staff, which merged to become the *Sun Herald*.

For the next thirty-plus years, I covered daily events as a journalist for the *Sun Herald*. The area that had been my family's vacation spot was now my home. Working as a writer and photographer for the newspaper, I served as the eyes of my community.

In doing so, I became accustomed to the traditions, cuisine, and always eccentric people of the Mississippi Gulf Coast. I have seen this area change from a sleepy shrimping town to a thriving casino resort destination.

While change seems to be a constant along the Coast, the people of Waveland, Bay St. Louis, Pass Christian, Long Beach, Gulfport, Biloxi, D'Iberville, Ocean Springs, Gautier, Pascagoula, Moss Point, and Escatawpa have never forgotten what it means to be a Coast resident.

During my years here, I came to love the area that I referred to as "the Coast" and now considered it my adopted hometown. It became all the more my home when my son was born in Gulfport. To this day, I feel more connection to the Mississippi Gulf Coast than any other place I have lived.

Hurricane Katrina

Prior to 2005, the history of the Mississippi Gulf Coast could be summed up as "BC—Before Camille" or "AC—After Camille." Veterans of the storm knew how strongly the winds blew and how far the water reached. In most people's minds, nothing would ever top Hurricane Camille.

On August 29, 2005, Hurricane Katrina wrought so much damage to the Mississippi Gulf Coast that the whole area looked like it had been bombed into oblivion. Unfortunately for Coast residents, the realization that there was a storm worse than Hurricane Camille became tragically evident. Homes, businesses, historic structures and people's dreams were all washed away by Katrina's fury.

While my house was still standing, I had fourteen trees down in my yard and three on my house. I remember standing in my yard and wondering, how do we recover from this? I also knew I was in better shape than some of my Coast friends.

My job was to take pictures of Katrina's damage. It hurt to shoot photographs of the area. This was my home; these were my neighbors, friends, and fellow Coast folks.

Throughout my career, my camera had always served as my shield. As long as it was in front of my face, I concentrated more on getting the picture than the sometimes-horrific scene in front of me. During Katrina, my shield did not work.

I recall a visiting journalist who asked me how I was coping. I told him, "It is hard to take pictures when you have tears in your eyes."

The Promise

While it was my job to document Katrina's damage, I grew tired of seeing all the demolished homes and broken lives. I remembered that the signature photograph from Hurricane Camille was the US flag still flying on a bent flag pole. I began searching for images to photograph that portrayed the hope, determination, and resilience that exemplified the people of the Mississippi Gulf Coast.

While documenting Katrina, I made a promise to myself to one day show the beauty of the Mississippi Gulf Coast. I did not want the nation's or the world's image of the Mississippi Gulf Coast to be a devastated and destroyed region.

For years, it was excruciatingly slow to live up to my promise. Out-of-this-world insurance rates kept homes and businesses from being rebuilt. The Coast suffered a triple hit of Hurricane Katrina, the economic collapse, and the BP oil spill, which hampered residents' efforts to get on with their lives.

Through it all, I began to notice once again the beauty of a sunrise. At first, I would watch the sun rise, admiring the brilliant colors.

On my days off and free time from work, I began to take pictures at dawn and dusk. I was once again seeing the beauty of the Mississippi Gulf Coast despite lingering reminders of Katrina.

A Promise Kept

The photographs that make up this book are my promise kept during those dark days after Hurricane Katrina. Initially, they were just for me, a relaxing way to begin my day. The sunrises were my solitary moments to thank God for another day and for a recovering Coast.

After a while, I decided to do a photographic homage to the place that I call home. I wanted to share this beauty with my family, friends, and anyone who loves and appreciates the Mississippi Gulf Coast.

I have written and taken photographs for numerous books relating to the Civil War and civil rights history. This book is my first effort to show the beauty of my home.

It is my hope that anyone looking at this book will see the beauty that I experience on a daily basis and understand why I continually thank God for these blessings. ■

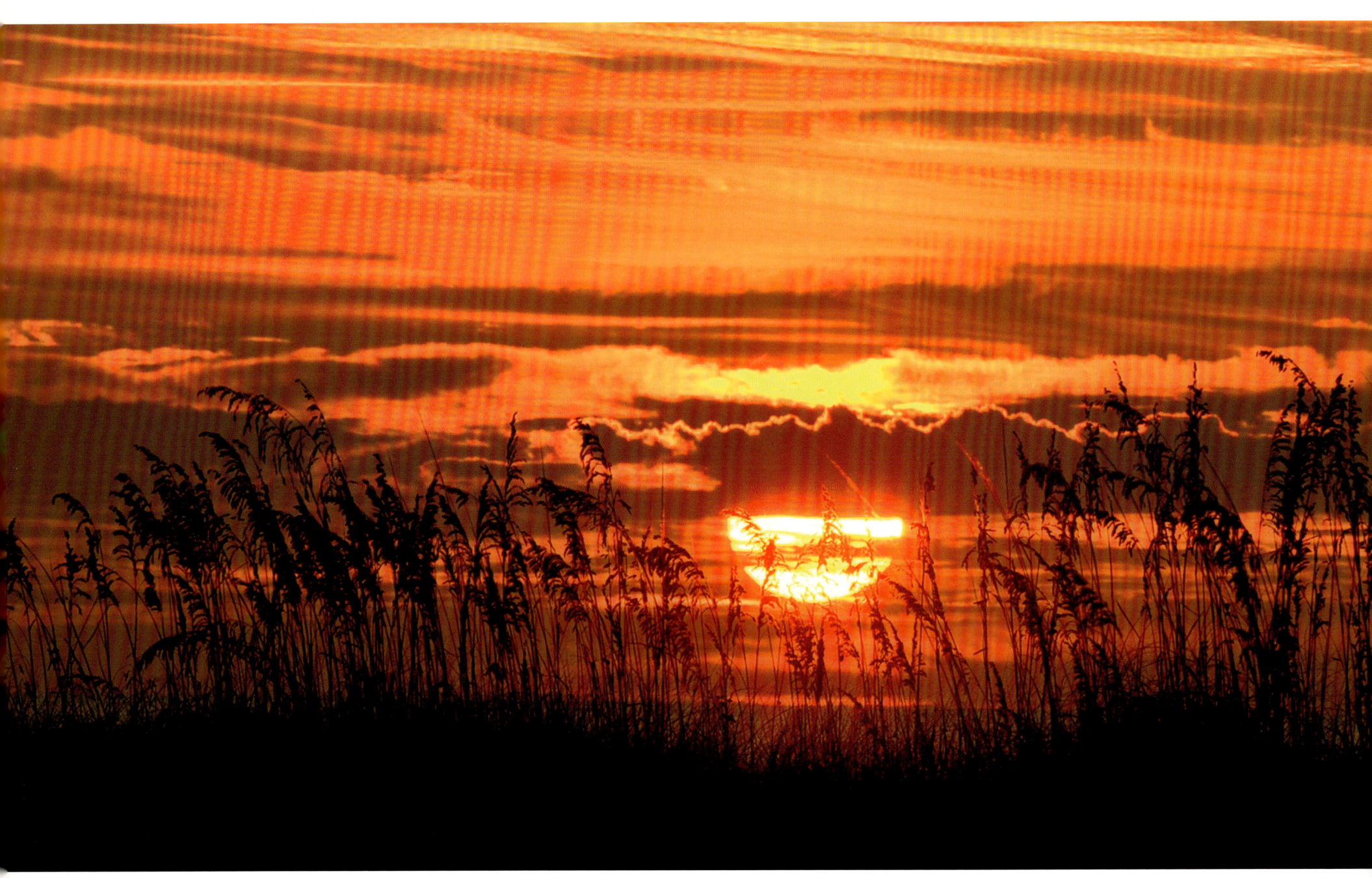

Sea oats and sunrise, Pass Christian, Mississippi

To the natural philosopher, the descriptive poet, the painter and the sculptor, as well as to the common observer, the power most important to cultivate, and, at the same time hardest to acquire, is that of seeing what is before him. Sight is a faculty; seeing, an art.
—**GEORGE PERKINS MARSH**

THE MISSISSIPPI GULF COAST

The Biloxi

The country is covered with very fine woods of oaks, poplars, copal trees, maples, cedars.
—PIERRE LE MOYNE D'IBERVILLE

The Coast was first inhabited by Native Americans. Small tribes of once-larger groups called the Coast home. Two of these tribes were the Biloxi and Pascagoula Indians. Little is known of these tribes prior to their contact with Europeans in the 1690s.

The Biloxi Indians were a small Siouan tribe, whose name meant "first people." They were an agrarian society and made pottery, wooden bowls, baskets, and horn and bone tools. They fished year-round and would augment their diet by hunting deer.

Control of the tribe or food storage facilities was entrusted to the *ayaaxi* or *yaaxi* (chief, medicine man, or shaman).

The Biloxi had a unique funeral practice for a deceased chief. Their bodies were dried in fire and smoke and placed in an upright position on red poles stuck into the ground in the central interior of a temple.

Food was offered to the deceased daily by visitors. These visitors were heartened to see the food disappear, most likely eaten by animals.

The Biloxi and Pascagoula Indians were the first inhabitants of the Mississippi Gulf Coast.

In the early 1700s, the Biloxi were persuaded to abandon their village and settle on a small bayou near New Orleans. By 1722, most of them had returned to a close proximity of their former home, settling on former lands of the Acolapissa Indians on the Pearl River. They remained there close to the Pascagoula until 1763, when French government east of the Mississippi came to an end.

As with most tribes, Indian legends were passed on from generation to generation. The Biloxi legend involves "the ring in the oak." The legend tells of an Indian couple of different tribes. The two wanted to marry, but the girl's father, who was chief, forbade the union. The father decreed that such a marriage could only take place when a ring formed in an oak branch. That night, a storm blew in from the gulf. The following morning, a perfect ring had formed in an oak tree. ■

The Pascagoula

> The chief of the Pascagoulas came to sing the peace calumet to us. He had in his following seven men of the same nation. I have never seen savages less embarrassed. They embraced us, a thing I have never seen the others do. They only pass the hand over the breast on their arrival, after having raised their arms to heaven.
> **—M. DE SAUVOLLE**

The Pascagoula Indians, whose name means "bread people," were the other tribe on the Mississippi Gulf Coast. The Pascagoula, first visited by Iberville in 1699, were peaceful people living along the banks of the Pascagoula River. They remained on the Coast and along the river that bears their name, often visiting their French friends at Fort Maurepas as long as the French were in power. When French rule ended, they moved to Louisiana.

A long-lasting legend of the Pascagoula involved what amounted to a mass suicide. Anola, a princess of the Biloxi tribe, fell in love with Altama, chief of the Pascagoula tribe. Anola was betrothed to a Biloxi chieftain but fled with Altama to the Pascagoula tribe. The Biloxi chieftain was enraged at being spurned by Anola and led his braves to battle against the Pascagoula.

The Pascagoula were at one time a powerful tribe, but constant wars with the Biloxi and other enemies had depleted their strength. Despite their small numbers, the Pascagoula swore to protect Anola and Altama or perish with them.

Altama and his tribe found themselves surrounded by the Biloxi. The odds were that the Biloxi would prevail, and the Pascagoula would be killed or enslaved. In order to escape this fate, the Pascagoula chose an alternative outcome. With women and children leading the procession, the Pascagoula began a death chant, walking hand-in-hand into the murky waters of what is now the Pascagoula River. As they reached deep water, they were carried, still clinging together and singing, out into the bay. Local legend maintains that the voices weren't silenced.

In 1985 a Jackson County resolution formally renamed a stretch of the Pascagoula River the Singing River. It is known for its mysterious music. Such music is best heard in the late evenings during late summer and autumn. At first, the music is barely heard until it grows louder and louder. ■

The Explorers

> We came in, under shelter of an island or the point of an island, where we are protected from winds from the south-southwest, south-southeast, and east by the island and from the northeast and the north and the northwest by the mainland, three and a half leagues from us, and from the west and southwest by an island two leagues away. We have found no less than 23 feet of water, and we are anchored a cannon's shot off the island in 26 feet of water.
> **—PIERRE LE MOYNE D'IBERVILLE,** describing Ship Island

While the Biloxi and Pascagoula Indians already called the Mississippi Gulf Coast home, Spanish explorers were the first to arrive in the state in 1528. It wasn't until the late 1680s that France and England began to play catch up with the Spaniards to cast their lot in this part of the new world.

Whether seeking the Fountain of Youth, Coronado, or new land, these three nations would play a role along the Mississippi Gulf Coast.

Rene-Robert Cavelier, Sieur de La Salle of France, had extensively explored the Great Lakes and the Ohio and Mississippi River basins. On April 9, 1682, La Salle, traveling down river, reached the mouth of the Mississippi River. In doing so, he claimed all the land between the Mobile River and the River of Palms in Mexico and all interior land from the Rockies and the Appalachians for Louis XIV. The territory was called Louisiana.

During July 1684, La Salle sailed from France with four ships and three hundred colonists, seeking to establish a colony at the mouth of the Mississippi River. He missed the river's mouth and sailed to present-day Texas. Suffering from harsh conditions, LaSalle's crew mutinied and murdered the French explorer.

Following in the footsteps of Spain's Hernando de Soto and France's La Salle, Pierre Le Moyne Sieur d'Iberville, of Canada, was entrusted to continue France's exploration of the Gulf Coast region. In 1697, the Comte de Pontchartrain, French minister of marine ordered Iberville to find and fortify the mouth of the Mississippi River. It was Iberville's turn to succeed where La Salle had failed. Accompanying

A French Footprint

If France does not seize this most beautiful part of America and set up a colony, [. . .] the English colony which is becoming quite large, will increase to such a degree that, in less than one hundred years, it will be strong enough to take over all of America and chase away all other nations.
—PIERRE LE MOYNE D'IBERVILLE

Having made landfall around Biloxi, Iberville continued westward, reaching the mouth of the Mississippi River on March 2, 1699. He then traveled two hundred miles inland, but failing to find a suitable location for settlement, he sent his brother, Bienville, and Lieutenant M. de Sauvolle back down river.

Iberville continued to explore the area in canoes, discovering two lakes, which he named Maurepas and Pontchartrain. Upon returning to the Gulf, Iberville discovered the mouth of the Pearl River.

By the end of March 1699, Iberville camped along the shore of the Bay of St. Louis. Once he reunited with his ships, Bienville presented Iberville with a piece of "talking bark," which had been given to him by an Indian chief during their journey

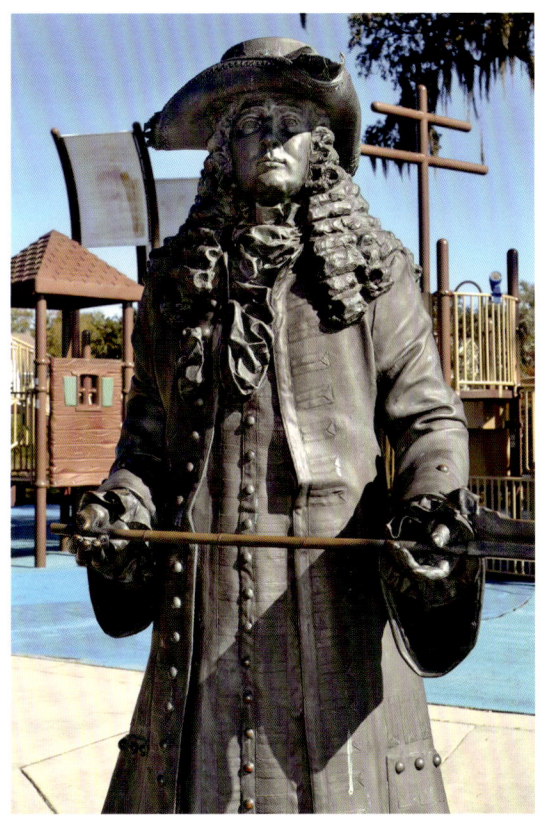

In 1699, Iberville claimed the Gulf Coast region for France.

French footsteps were first seen on the shores of the Mississippi Gulf Coast in 1699.

Iberville was his younger brother, Jean Baptiste Le Moyne, Sieur de Bienville. The two brothers were destined to be forever affiliated with the Mississippi Gulf Coast.

On January 26, 1699, Iberville's two vessels, the *Marin* and the *Badine*, arrived at Pensacola Bay in need of supplies and fresh water.

The Spaniards were not inclined to be receptive of the French vessels, denying them entry into the bay. Instead, they sent them water and wood. Iberville continued westward, renewing his search for a deep-water location to claim for France. On February 10, 1699, Iberville dropped anchor at Ship Island, and on February 13, he and fourteen crewmen landed at present-day Biloxi.

In four days, Iberville's Frenchmen fostered a friendship with the Biloxi. In 1699, it was estimated that four hundred Indians called the Mississippi Gulf Coast home. These included the Biloxi and Pascagoula, who lived on the Pascagoula River; the Acolopissas, who lived along the Pearl River; and the Bayogoula, who lived along the bayous of Mississippi and Louisiana. These numbers continued to drop due to continued warfare between the tribes and the introduction of diseases by European explorers. The peace agreement between Iberville and the Coast Indian tribes continued throughout the sixty-four years the Mississippi Gulf Coast was under French rule. ■

down the Mississippi River to the Gulf. The bark was a note written by Henri de Tonti, better known as "Iron Hand," which had been written fourteen years earlier and intended for La Salle, who had missed the mouth of the Mississippi during his journey from France. Iron Hand's note reaffirmed that Iberville had indeed located the mouth of the Mississippi River.

Needing to build a fort of some sort, Iberville chose to leave his boats moored at Ship Island and built a temporary fortification on the east side of Biloxi Bay. While this location is referred to as Old Biloxi, it is now present-day Ocean Springs.

By April 24, 1699, Iberville had his fort. A journal entry from the vessel *Marin* describes the structure: "The fort was made with four bastions, two of them squared logs, from two to three feet thick, placed one upon the other, with embrasures for port holes and a ditch all around. The other two bastions were stockaded with heavy timbers which took four men to lift one of them. Twelve guns were mounted."

In a report to the French minister of marine, Iberville referred to the fort as Maurepas.

Before returning to France, Iberville left eighty-one men at the fort, commanded by M. de Sauvolle, a Frenchman by birth, who was an ensign on the *Marin* and was described by Iberville as "a wise young man."

Staying in the New World with Sauvolle was Iberville's brother, Bienville. ■

Bienville's Reign

God wills that Frenchmen live in this country in order to spread the Catholic religion to His glory and at the same time to found a second French empire to the glory of His Most Christian Majesty.
—ANDRE JOSEPH PENICAULT

With Iberville in France and Sauvolle minding Fort Maurepas, Bienville continued exploration of the Mississippi Sound, stretching from what is now Mobile Bay to the Mississippi River.

During his exploration east of Fort Maurepas, Bienville discovered Mobile Bay. Iberville had missed this location on his first journey along the Mississippi Sound.

On August 25, 1699, Bienville explored the Bay of St. Louis. Andre' Joseph Penicault, a ship's carpenter on the expedition, recorded in his journals: "We shortly afterwards found a beautiful bay, about one league in width, by four in circumference, which M. Bienville named the Bay of St. Louis, because it was on the feast day of St. Louis we arrived there. We hunted there three days and killed fifty deer" (McWilliams 96).

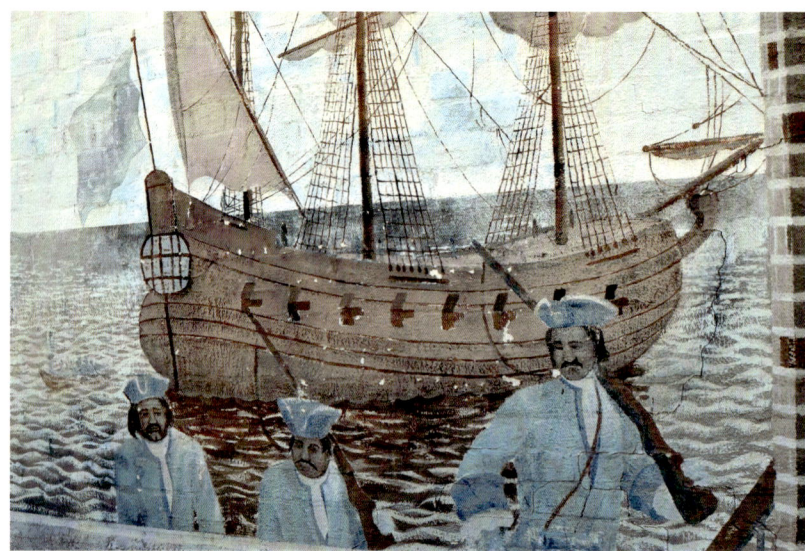

When Iberville returned to France, Bienville continued to explore the Gulf Coast waters, including the Bay of St. Louis.

Iberville returned to Fort Maurepas in January 1700. Bienville told his brother of his encounter with an English warship on a bend of the Mississippi River four months earlier. With only five men and two canoes, Bienville had bluffed the English. Realizing that they intended to claim the Mississippi River for their country, Bienville boarded the vessel, ordering them to withdraw or be sunk by the guns of French forts upstream. The English believed Bienville's bluff and retreated downriver. This area of the Mississippi River is still called "English Turn."

Upon hearing Bienville's story, Iberville ordered a French fort to be built on the river. This was Fort Mississippi, located fifty-four miles north of the river's mouth.

After Sauvolle's death in 1701, Bienville, who was second in command to Sauvolle, was commissioned commandant of the colony located at New Biloxi. Meanwhile, England declared war on France and Spain. Iberville ordered the destruction of Fort Maurepas and a new fort built at Mobile Bay, which was closer to their Spanish allies in Pensacola.

In April 1702, Iberville left the New French Coast for the last time to return to France, but he died in Havana, Cuba. From 1701 to 1743, Bienville served the New French Colony in various roles ranging from second in command, to explorer and commandant. During those years, he shepherded the New French Colony, stretching between Mobile, Alabama, and New Orleans, Louisiana, through famine, natural disasters, and war with England.

Bienville remained at Mobile until January 1720, when he moved the capital back to Biloxi. Although it was a flood risk, Bienville moved the capital from Biloxi to New Orleans in 1723. Bienville's longest tenure as governor was from 1733 through 1743.

The move of the capital from Biloxi to New Orleans, along with a hurricane, spelled doom for the settlements along the Mississippi Gulf Coast. Most residents along the Coast fled to either Mobile or New Orleans. ■

British Rule

The peace was insecure because it restored the enemy to her former greatness. The peace was inadequate, because the places gained were no equivalent for the places surrendered.
—WILLIAM PITT, the Elder

The Seven Years' War, which took place between 1754 and 1763, ended in defeat for France and Spain. The war began and was driven by friction by European powers of that time. Great Britain was in competition with France and Spain over trade and new colonies.

The 1763 Treaty of Paris between France, Spain, and Great Britain gave the English possession of many of France and Spain's New World colonies. Spain received all French holdings west of the Mississippi River, including New Orleans. Meanwhile, Great Britain received French holdings east of the Mississippi River. This was known as British West Florida and included the Mississippi Gulf Coast.

For those remaining on the Mississippi Gulf Coast, life under British rule was one of isolation. Although Great Britain planned to build strategically placed forts along the Coast in an effort to slow trade at Spanish-controlled New Orleans, little was completed. Those who remained on the Mississippi Gulf Coast made a meager living of supplying lumber, pitch, tar, and charcoal from abundant pine forests. Given their isolation, these isolated residents traded with Spanish-controlled New Orleans. At Pascagoula, a large boat was constructed to carry goods such as deerskin and corn to trade with Choctaw Indians up river.

In 1775, the British crown designated West Florida as a refuge for Tories from Georgia and Carolina who had refused to take part in the American Revolution. This meant a land grab for many new inhabitants along the Coast and further inland.

When France became an ally of the thirteen colonies at war with Great Britain, French-speaking inhabitants along the Coast tried to coerce the Spanish into siding with them and the colonists.

Spain ruled Spanish West Florida for twenty-one years before ceding the region back to France, which then sold it to the United States.

In June 1779, Spain declared war on Great Britain, capturing Natchez, Baton Rouge, and other locations. Using Ship Island as a staging area, the Spanish, under the command of Bernardo Galvez, first bombarded Mobile and Pensacola.

The Treaty of Paris of 1783 ended the American Revolution with the newly formed United States of America as the victor. Separate treaties were also signed with allies of America, including France and Spain. In the treaty with Spain, it was agreed upon that British West Florida would become Spanish West Florida. ■

Raising the Lions and Castles

You will receive from the Secretary of State a commission as governor of the Mississippi territory, an office which I consider of primary importance, inasmuch as that country is the principal point of contact between Spain and us, & also as it is the embryo of a very great state.
—THOMAS JEFFERSON, letter to William C. C. Claiborne

Spanish rule began with Galvez confirming land holdings by inhabitants along the Coast. Moreover, Spain granted more new tracts to new inhabitants.

Before long, the newly formed America and the Spanish government fought over boundaries of West Florida. America favored the thirty-first parallel as Spanish West

Florida's northern border. Meanwhile, the Spanish maintained the line began at the mouth of the Yazoo River. It wasn't until 1795 that Spain accepted the thirty-first parallel as the northern border of Spanish West Florida.

On April 7, 1798, the American Congress created the Mississippi Territory. Bordered on the south by the thirty-first parallel, on the north by the Tennessee border, on the west by the Mississippi River, and on the east by the Apalachicola-Chattahoochee line, the Mississippi Territory made up present-day Mississippi and Alabama. The notable exception was the coastal panhandle of each future state, which remained part of Spanish West Florida.

The Mississippi Territory became the new Promised Land and frontier for settlers who failed to secure land in the original thirteen colonies. One Mississippi immigrant, Captain Basil Hall, described his new home as "a wide empty country with a soil that yields such noble crops that any man is sure to succeed" (Hodgson 141).

For the next twenty years, this move south and west was known at the Great Migration. Spain tried to maintain control of their area by creating a 12 percent tariff on commercial cargo that traveled north and south on the Pearl and Pascagoula Rivers in present-day Mississippi and rivers entering Mobile Bay.

Napoleon Bonaparte forced Spain to cede the Louisiana Territory back to France. In 1804, France sold this land to the United States. Still, Spain continued to claim possession of West Florida.

Angered by their exclusion from the Mississippi Territory, inhabitants of West Florida began to make life uneasy for the Spanish, staging uprisings in St. Francisville and Baton Rouge. Although these uprisings were initially quelled, life was a balancing act for Spain and the inhabitants of West Florida. ∎

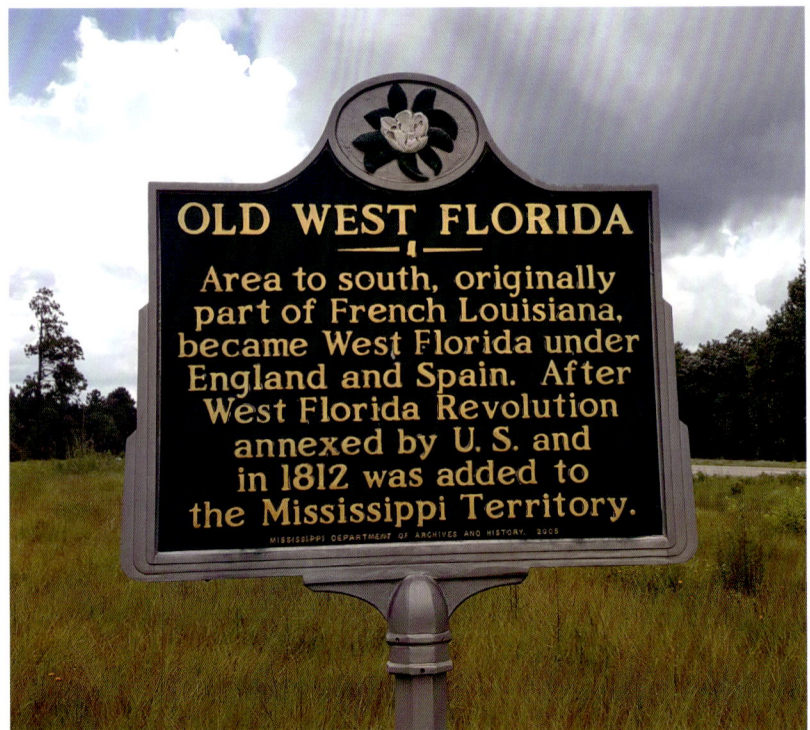

The southern counties of Mississippi were originally part of West Florida, until it was annexed in 1812 to the Mississippi Territory.

Republic of West Florida

I live in hopes as I make no doubt you know the value of West Florida too well to give it up by treaty on anywise to any power on earth.
—OLIVER POLLOCK

Tired of Spanish rule when the rest of the Mississippi Territory was part of the United States, residents of the coastal area of Mississippi and Alabama began to fan the wind of rebellion.

On September 23, 1810, residents seized the fort at Baton Rouge. The Spanish flag was replaced by a banner that bore a lone white star on a field of blue. In St. Francisville, leaders proclaimed this new territory the independent Republic of West Florida.

By October 27, 1810, President James Madison issued a proclamation that annexed West Florida to the Louisiana Purchase. Less than two months later, the West Florida rebellion would reach the Mississippi Gulf Coast.

On December, 4, 1810, Sterling Dupree and his recruits rowed down the Pascagoula River and seized the Spanish fort at Pascagoula. Dupree raised the Lone Star flag before returning to his home on the thirty-first parallel near the Pascagoula River.

The rebellion of West Florida had a short life, as did the fledgling republic. The Republic of West Florida only lasted seventy-four days until American troops arrived, raising the Stars and Stripes over the newly annexed area.

The area between the Pearl River and Biloxi Bay was the Parish of Biloxi, and the area from Biloxi Bay to Perdido was the Parish of Pascagoula.

In April 1812, Louisiana became a new state. Meanwhile, the land between the Pearl River and Perdido became part of the Mississippi Territory. Two months later, America declared war on Great Britain, beginning the War of 1812. The Mississippi Gulf Coast was destined to play a role in one of the war's most significant battles. ∎

War of 1812

Of all the enemies to public liberty, war is perhaps the most to be dreaded because it comprises and develops the germ of every other.
—JAMES MADISON

Spain sided with the British and opened its ports in North America to its new ally. Then, the Spanish incited Creek Indian allies to attack Americans as they moved west toward the new territories.

Dupree, along with George Nixon and John Bond of the Pearl River area, led a contingent of men from the Mississippi Territory to first deal with the Creek Indians and eventually the British.

Andrew Jackson, a temperamental backwoods leader, served as general to lead these volunteers and his Tennessee Militia. On March 27, 1814, Jackson's men wiped out the Creek Indians at the battle of Horseshoe Bend. With the Indians no longer an issue, Jackson had the public support and important victory that would catapult him to command and defend the Gulf Coast region.

The Madison administration, still reeling from the British attack and burning of Washington DC, sent representatives to talk peace settlement with the British at Ghent, Belgium. Meanwhile, the British sent troops toward New Orleans. Their goal was to attack up the Mississippi River and link up with British forces in Canada. Such a move would serve to split the United States in half.

As Jackson made his way overland to New Orleans, a British armada could be seen on the horizon off the Mississippi Gulf Coast. On December 12, 1814, this armada, with twenty thousand veteran soldiers and sailors, approached the Mississippi Gulf Coast.

Beginning at Pass Christian, a five-boat fleet under the command of Ap Catesby Jones fought a delaying action against the British. Jones fell back to the Bay of St. Louis where he fought for half an hour before blowing up one vessel. Jones retreated to the Rigolets where he made his stand against the British. After a two-hour fight, he surrendered to the British. Meanwhile, he had bought time for Jackson at New Orleans.

On December 25, 1814, British and American representatives signed the Treaty of Ghent, ending the War of 1812. News was slow to reach Jackson. On January 8, 1815, volunteers, free blacks, Creoles, and pirates combined to defeat the British army at the Battle of New Orleans. ■

Statehood and the Six Sisters

Our country may be likened to a new house. We lack many things, but we possess the most precious of all—liberty!
—JAMES MONROE

With the young nation once again at peace, the Great Migration resumed, and population grew in the Mississippi Territory, causing people to talk of statehood.

In 1817, what was the Mississippi Territory became the state of Mississippi and the Alabama Territory. Two years later, Alabama also became a state.

Now a member of the United States of America, the antebellum period in Mississippi was one of growth and extreme wealth for a few, hard work and moderate growth for others and dehumanizing enslavement of many.

Along the Mississippi Gulf Coast, resort spas that primarily serviced the metropolitan areas of New Orleans, Mobile, and Natchez began to thrive. These watering places were referred to as the "Six Sisters." These sisters were Shieldsboro (Bay St. Louis), Pass Christian, Mississippi City, Biloxi, Ocean Springs, and the Pascagoulas (east and west).

During the antebellum period, the Six Sisters were primarily accessible by water, as roads were a luxury not yet prevalent on the Coast. The advent of the steamboat meant a water connection between New Orleans and Mobile, with stops at all the villages of the Six Sisters.

British control of the Mississippi Gulf Coast was between the French and Spanish rule. It lasted from 1763 to 1783.

The first steamboat service from New Orleans to Mobile began in 1827. At first, such a line was challenging at best. Steamboats had to avoid shallow water and had to divert to the Gulf around Ship Island. This challenge was made easier thanks to Captain John Grant, who was hired to dredge Mobile Bay and build a railroad from New Orleans to steamboat docks at Milneburg.

In 1839, Grant dredged a pass from Dauphin Island to the Mississippi Sound, allowing a sheltered connection from the Mississippi Sound to Mobile. Grant owned houses in New Orleans, Mobile, and Pascagoula. Grant spent the most time in Pascagoula. His home was located at Grant's Lake, and he helped build the town's first church. He also served on the legislatures of Mississippi, Alabama, and Louisiana. For his efforts, Grant was given the title of "Father of Gulf Coast Transportation." He is buried in Pascagoula.

The Six Sisters did their best to take advantage of the nautical travel along the Coast. ■

The Pass Christian Yacht Club is the second oldest yacht club in the United States.

Hotels and Regattas

The west wing of the hotel has been finished and considerable improvements have been made in various ways to render this not only the largest but one of the most desirable watering places on the Lake.
—NEW ORLEANS DAILY PICAYUNE, describing the Pass Christian Hotel

As the Sisters continued their rise in popularity as a destination, hotels were built to provide places to stay for those traveling to the Coast. These hotels were alternatives to the boarding houses already in each town.

Bay St. Louis had two hotels. At each hotel, long wharfs were built to allow vessels the ability to dock year-round without fear of running aground.

Further to the east, an establishment soon opened that served as the crown jewel of the antebellum Coast. On May 18, 1838, the Pass Christian Hotel opened and was lauded as the "Saratoga of the South." The hotel faced the Mississippi Sound and the wharf leading from the water to the hotel. It was a popular gathering spot for New Orleans elite who viewed the Mississippi Gulf Coast as an extension of Louisiana. Fourth of July celebrations were always a grand spectacle there. In 1848, the Pass Christian Hotel played host to Mexican War hero and future president Zachary Taylor.

Since the Coast area served as a prime location for summer homes of New Orleans and Mobile residents, it was only fitting that a historic custom was born on the Coast.

On July 11, 1849, R. H. Montgomery, manager of the Pass Christian Hotel, announced a sailboat race, which was to be held in conjunction with the forming of a sailing club. The first such race was won by the *Flirt of Biloxi*.

The *New Orleans Daily Picayune* maintained, "A new era in our sports has suddenly arrived." This brought about the formation of the Southern Regatta Club, which became the Pass Christian Yacht Club, which holds the distinction of being the second oldest yacht club in the country. ■

A Lasting Coast Landmark

The Biloxi Lighthouse has been a symbol of maritime safety, hope and goodwill since it was constructed in 1848, and today stands proudly as an icon of Gulf Coast life. Since Hurricane Katrina struck in 2005—the worst natural disaster in American history—the lighthouse has assumed an even greater role, symbolizing the indomitable spirit and determination of Gulf Coast residents to recover and rebuild bigger and better than ever.
—HALEY BARBOUR

On February 8, 1838, Biloxi was the last of the Six Sisters to be chartered as a town. It quickly grew to become the largest town at the end of the antebellum period.

By 1847, Biloxi could boast of a population of six hundred inhabitants. The *New Orleans Daily Delta* (circa 1850) said of Biloxi, "The town is right on the sea. There is no long beach to traverse before you can reach the sea" (Sullivan and Powell 58). Its role as a tourist destination continued to grow as the town with six hotels lining the water's edge. Some of the Biloxi hotels included Nixon's Hotel, Shady Grove Hotel,

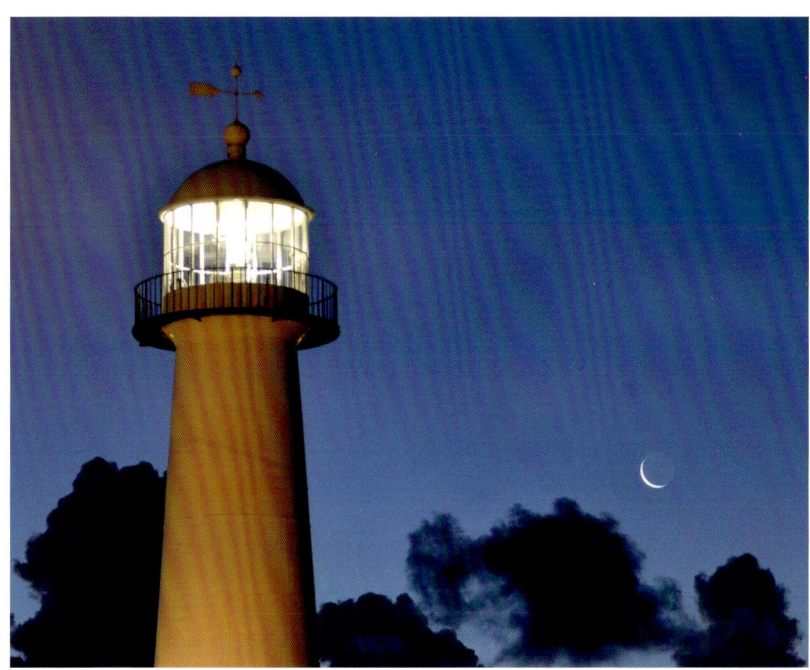

The Biloxi Lighthouse, the enduring symbol of the Mississippi Gulf Coast, was completed in 1848.

Bachelor's Hall, and Pradat's Hotel. The Magnolia Hotel, which opened in 1847, is the only surviving antebellum hotel. Today, it serves as the Mardi Gras museum in downtown Biloxi.

In the summer of 1848, the Biloxi Lighthouse began its long service for the community. Since it opened, the Lighthouse has stood through the Civil War to the War in Afghanistan. It has stood through the 1853 Yellow Fever epidemic and weathered storms such as Hurricanes Betsy, Camille, Elena, Georges, Katrina, and Isaac. It is the only lighthouse to stand in the middle of a four-lane highway. It is also the most photographed structure on the Mississippi Gulf Coast.

In 1858, a visitor said of Biloxi,

> This is too much of a town to be very pleasant as a summer resort. About the wharf is a perfect fish market—inhabited by a class of people who are anything but quiet. Nevertheless, it is a place of great resort . . . The hotels are full nearly all the time. The fishing is good—and they know how to serve them up. Biloxi is universally celebrated as the place to get a good fish dinner. The roads are good in the immediate neighborhood of the town and it is very shady. It is a great place for children. I have seen more here for the number of adults around than I ever saw at any other place. (Sullivan and Powell 62) ■

The Coast and Civil War

The possession and fortification of Ship Island and all those other small islands lying just off the mainland, would be of immense importance.
—**JOHN J. PETTUS,** Mississippi Governor

Although the Coast was sparsely populated and had precious few plantations and slaves, residents strongly supported Pettus. Compared to the rest of the state, the Coast had a few free blacks. The Coast was less populated by slaves, too. In the Mississippi Delta, slaves outnumbered whites fifteen to one. Despite these facts, the majority of Coast residents supported southern arguments protecting slavery and states' rights.

When Mississippi seceded, one of the first issues was what to do with the unnamed fort currently under construction on Ship Island. In January 1861, the fort walls were at nine feet. It was the only federal installation in Mississippi.

On January 13, 1861, local militia, including the Biloxi Rifles and the Handsboro Minute Men, landed at Ship Island and informed the fort overseer that they were taking possession of the fort and island. The overseer continued construction on the fort until January 20, when an armed party ordered the Federals off the island. The takeover of Ship Island occurred three months before the official start of the war, when Confederate troops fired on Fort Sumter in April 1861. Although the island was in Mississippi hands, Pettus had no arms that he could provide for the defense of the fort, and Ship Island was soon deserted.

After Fort Sumter was attacked, Lincoln ordered a blockade of the Southern coastline. Although war had begun, the Coast was engaged in the more romantic aspect of war. Local militias were hailed and honored at Coast picnics. Bands played as local militia men assembled under live oaks. They were presented regimental banners made by local women. The Coast defenders were given the charge to "conquer or die." Some defenders would stay on the Coast, while others were sent to destinations in Mississippi or in the fledgling Confederacy.

Although the nation was at Civil War, the Coast, which was the vacation spot for the elite of New Orleans and Mobile as well as the upstate planter class, was still open for the upcoming summer season. ■

Soldiers named the fort under construction on Ship Island Massachusetts after the steamer and its crew that secured the island for the Union.

The Massachusetts

Here we intend to stay and keep "watch and ward" over this "Isle of tranquil delight" in spite of mosquitoes, hot suns, bilge water, live Yankees and big ships.
—**H. W. ALLEN,** Confederate Commander at Ship Island

On June 17, 1861, Melancton Smith and the steamer USS *Massachusetts* made their first appearance on the Coast. After catching the schooner *Achilles*, Smith raised the US flag over the fort still under construction on Ship Island.

The following day, Biloxi mayor James Fewell ordered the lamp in the Biloxi Lighthouse extinguished. The lighthouse would not be a beacon for vessels for five and a half years.

The *Achilles* was armed and outfitted to operate within the Mississippi Sound, while the *Massachusetts* patrolled outside the barrier islands. David Twiggs called for local mail steamers to transport troops and material to Ship Island. The troops extinguished the lamp at the Ship Island Lighthouse and christened the unfinished works Fort Twiggs.

Upon returning to the vicinity of Ship Island, Smith spied Confederate flags and four batteries on the island. Smith sailed for the island exchanging fire with the soldiers. The twenty-minute fight ended with the *Massachusetts* anchoring outside of gun range.

During the next two months, Confederates strengthened the fortifications at Ship Island. Meanwhile, Charles Dahlgren arrived in Pass Christian to assume command of Confederate troops on the Mississippi Gulf Coast.

As the number of Confederates grew on the Coast, more of the Federal blockade flotilla arrived near Ship Island. Jefferson Davis ordered the evacuation of Ship Island. On September 16, 1861, Confederates burned the lighthouse and left Ship Island.

Upon reaching Ship Island, Federals found a note left for them by the island's Confederate defenders. The note bid farewell and best wishes for their health during their stay on Ship Island's "pleasant hospitable shore." ∎

Coast Operations

At the request of General Butler, I have today sent the Jackson and New London to cooperate with a portion of the army in one of the steamers against the rebels at Biloxi and Pass Christian for their having fired on a flag of truce.
—**GEORGE EMMONS**

In March 1862, Biloxi barely escaped destruction at the hands of the Union army. An injured four-year-old girl and seventeen other survivors were rescued from the blockade runner *Black Joker* when it floundered in rough waters and taken to Ship Island. They were brought to General Benjamin Butler, who charged George Strong to bring the girl to Biloxi so she could be sent back to her family in New Orleans.

Under a flag of truce, Strong delivered the girl to Biloxi. Upon leaving, Strong ran aground at Deer Island. While his vessel was stuck, he was fired on twice by persons in Biloxi. They then sailed out to demand Strong's surrender. Strong refused and was able to make his escape to Ship Island.

Upon hearing Strong's story, Butler was incensed and demanded a written apology from Biloxi's mayor for its citizens' "cowardly conduct." To get his point across, three Union gunboats and one thousand soldiers from the Ninth Connecticut were prepared to do damage to the town. Butler got his apology, and Biloxians were warned that another such action would bring about the destruction of their town.

While on the Coast, the Federals tried to secure a truce with Colonel John Deason, Third Mississippi Infantry, Regiment C. Instead, they were fired upon by Confederate gunboats. After a two-hour fight, the Confederate vessels fled toward the back waters. Meanwhile, the Federals sailed to Pass Christian to attack Deason's camp.

Upon seeing the Federal vessels approach, Confederates set fire to cotton bales on the Pass Christian wharfs. Mistaking the burning bales for artillery fire, the Union boats opened fire on Pass Christian.

Once ashore, the Ninth Connecticut marched to the Third Mississippi's encampment, driving off a small detachment of Confederates. The camp was destroyed, and a Mississippi Magnolia flag, which served as the regimental banner, was captured. ∎

The Native Guard

I am not indifferent to the claims of a general forgetfulness, but whatever else I may forget, I shall never forget the difference between those who fought for liberty and those who fought for slavery; between those who fought to save the Republic and those who fought to destroy it. If this war is to be forgotten, I ask in the name of all things sacred what shall men remember?
—**FREDERICK DOUGLASS**

During the Civil War, twenty-seven Union regiments served on Ship Island. The regiment that had the longest tenure there was the Second Louisiana Native Guard, an African American regiment from the New Orleans area. The Native Guard, under the command of Nathan Daniels, arrived at Ship Island for garrison duty on January 12, 1863.

Initially, the Guard shared duty with the Thirteenth Maine, a white regiment already on Ship Island. The mixture of a white regiment and a black regiment didn't work, and within a week, a racial dispute broke out between them. The Native Guard had to deal with racism from the North and South. Despite this added burden, the men persevered, proving on April, 9, 1863, that they could do more than garrison duty, when they served as a fighting regiment during a raid on Pascagoula. There, they clashed with Confederate troops, making the Second Louisiana the first black unit engaged in combat on the Gulf Coast.

Although outnumbered, Daniels and the Native Guard were able to repel Confederate attacks. This was done without the naval support of the USS *Jackson*.

Two months earlier, there had been an incident between a member of the Native Guard and a white sailor from the *Jackson*. Even though the Guard and the *Jackson* crew all wore Union blue, the sailors did little to aid the Guard in the fight in Pascagoula. Daniels felt the Native Guard was fighting the white crew of the *Jackson* as well as the Confederates on shore. The *Jackson* fired an artillery round into the Guard's ranks, killing five and wounding seven more.

By October 1864, the first Confederate prisoners were transported to Ship Island. The Native Guard was on hand to oversee the new influx of prisoners, many of whom came from New Orleans. In April 1865, three thousand Confederate prisoners were sent to Ship Island after the fall of Mobile.

During the Civil War, 153 Confederate prisoners and 232 Union soldiers died on Ship Island. By June 8, 1865, no prisoners remained on Ship Island. On October 11, 1865, the Second Louisiana Native Guard, which was redesignated the Seventy-Fourth Infantry United States Colored Troops, was mustered out of service.

Daniels wrote of his regiment, "Thank God for my Regiment, an African one, that I have been permitted to assemble under the banner of freedom to do and die for their country & liberty" (Weaver xvii, 214).

In 2007, Natasha Trethewey won the Pulitzer Prize in Poetry for her 2006 collection *Native Guard,* which tells the story of the Louisiana Native Guard serving on Ship Island. Born on Confederate Memorial Day, one hundred years after the war, Trethewey said she could not have escaped learning about the Civil War and what it represented. She explained that she had been fascinated by the Civil War since childhood.

On June 7, 2012, James Billington, the librarian of Congress, named Trethewey the nineteenth US poet laureate. Billington said he was "immediately struck by a kind of classic quality with a richness and variety of structures with which she presents her poetry . . . she intermixes her story with the historical story in a way that takes you deep into the human tragedy of it." Trethewey was the first laureate to live in Washington, DC, during her tenure. ∎

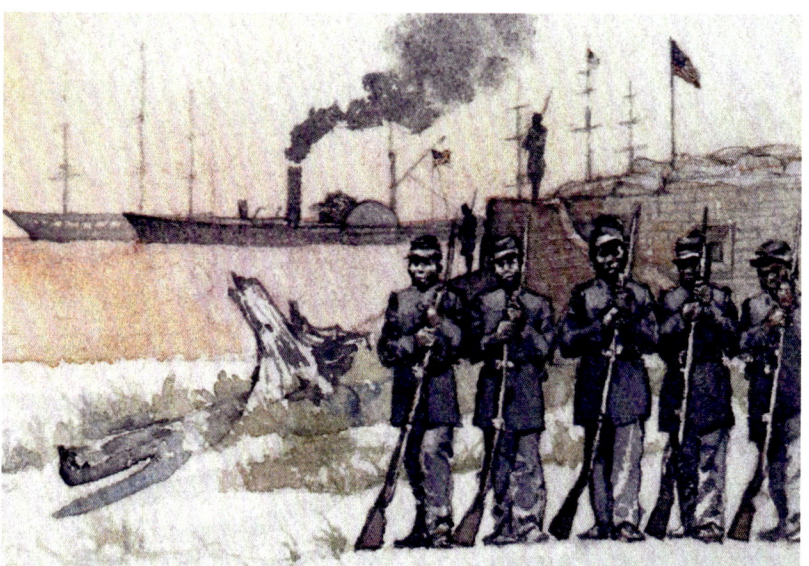

The Second Louisiana Native Guard, an African American regiment from New Orleans that served on Ship Island.

Starvation and War's End

To secede from the Union and set up another government would cause war. If you go to war with the United States, you will never conquer her, as she has the money and the men. If she does not whip you by guns, powder and steel, she will starve you too.
—SAM HOUSTON

By the end of the Civil War, the remaining Mississippi Gulf Coast residents had suffered from starvation.

A. R. Yates, a Union gunboat captain, was unnerved by the misery exhibited by Coast residents. Yates landed his gunboat in Biloxi and gave his ship's stores to the townspeople.

A resident from Mississippi City slipped Yates a letter describing the plight of Coast residents. The letter explained that the area soil was not conducive to heavy farming. Four years of war had also kept Coast families from having salt to preserve meat. The letter explained, "There are fifty families, women and children, that will starve if the Government does not come to their relief. Many of them have not tasted meat for months. Many more are now living on roots and fish."

Yates sent the message to the admiral in command of the West Gulf Blockading Squadron. Yates was told to feed anyone who would take an oath of allegiance to the United States.

On April 9, 1865, Robert E. Lee surrendered to Ulysses S. Grant at Appomattox. This was followed by Joseph E. Johnston's surrender to William T. Sherman on April 26, 1865. Closer to the Coast, Richard Taylor surrendered to E. R. S. Canby on May 4, 1865 at Citronelle, Alabama.

The Confederates of the Trans Mississippi were the last to surrender. Stand Watie surrendered the last significant Confederate forces on June 23, 1865. On November 6, 1865, James Waddell surrendered the CSS *Shenandoah*.

On August 20, 1866, President Andrew Johnson signed a proclamation stating that "peace, order, tranquility, and civil authority now exists in and Throughout the Whole of the United States of America." ∎

A Lost Generation

I felt like anything rather than rejoicing at the downfall of a foe who had fought so long and valiantly, and had suffered so much for a cause that was, I believe, one of the worst for which a people ever fought, and one for which there was the least excuse.
—ULYSSES S. GRANT

The Mississippi Gulf Coast was not unlike any other city or town after the Civil War. The war that ripped apart a nation produced more than 626,000 deaths and 1 million casualties.

The task of rebuilding a nation would come without the input or production of the best and brightest of each community. Due to the horrors of war, many of these had fallen on battlefields such as Manassas, Shiloh, Chancellorsville, Gettysburg, Vicksburg, Chickamauga, the Wilderness, Cold Harbor, Franklin, and other places too numerous to mention.

When Johnny came "marching home," it was evident that the returning veterans of the Biloxi Rifles, Dahlgren Guards, Shieldsboro Rifles, Live Oak Rifles, and Gainesville Volunteers were few in number. Of the Live Oak Rifles of Ocean Springs, only seven of the 210 volunteers who marched to war and glory returned. ∎

Turkey Creek

Without a struggle, there can be no progress.
—FREDERICK DOUGLASS

In 1866, former slaves bought 320 acres of land that the federal government had designated as a swamp. The historic community of Turkey Creek was born on the hard work of the pioneers ready to begin a new life as "freed men."

The toll of the Civil War was evident as families mourned the absence of many of Mississippi's sons who gave their last full measure.

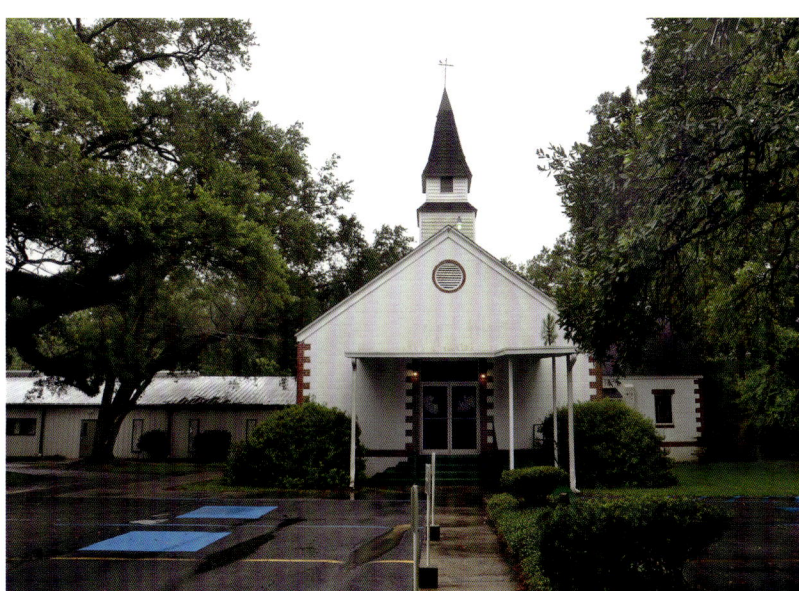

Mt. Pleasant United Methodist Church serves as the focal point for the area known as Turkey Creek. Former slaves bought the property after the Civil War.

To make Turkey Creek a thriving community, residents had to overcome the marshy swampland and geographical isolation. They turned the swampland into productive farmland, producing vegetables to sell at the market.

The community consisted of more than just homes and farmland. Schools and churches were also built for the local residents. The Mount Pleasant United Methodist Church serves as the focal point for the Turkey Creek community.

The creek, with its brackish water, was the lifeblood of the community. Residents used its water for refreshment, irrigation, and a source of food. It was also used for spiritual cleansing, as many of the residents were baptized in Turkey Creek.

During the days of the segregated South, blacks could not go to the beach, but the winding creek served as a place of recreation for those in the community. Whether playing ball on a nearby field, resting under the shade of live oaks, or just swimming in the stream, Turkey Creek and the cool water and woods stretching along Turkey Creek were a haven.

The Turkey Creek community is actually older than the town in which it currently resides. The city of Gulfport, Mississippi, was founded on July 28, 1898. By that time, Turkey Creek was already thirty-two years old and self-sufficient.

Today, Gulfport is the second largest city in Mississippi, and Turkey Creek has been swallowed up by the growth of the town. The expansion of Gulfport hasn't always been kind to Turkey Creek. After much of the Turkey Creek land was zoned commercial, developers quickly snatched up any available property. Virtually all of a historic cemetery was flattened in order to make room for commercial development. The area was further devastated in 2005 by Hurricane Katrina, as Turkey Creek inundated many of the homes that had stood nearby.

Turkey Creek is listed on the National Register of Historic Places. Despite this recognition, the community remains in peril. The Mississippi Heritage Trust listed the entire Turkey Creek community as one of the state's Ten Most Endangered Historical Places. ■

Commerce Gets Back on "Track"

We have had one great help—the railroad. It has literally clothed the naked and fed the hungry. It has given employment at high wages to every man who would work. And if there be . . . a man who cannot say from the bottom of his heart, God bless this great enterprise and all concerned with it, he must be a thankless fellow indeed.
—HANDSBORO DEMOCRAT

The true sign of better times was eventually evident on the Coast. Towns that had been desolate during the war began to show signs of life. Shops and businesses reopened for patrons and visitors. The Coast's summer season was renewed with the opening of new hotels in Mississippi City and Ocean Springs. Maritime vessels, which once sported armor and guns of warfare, were stripped of their armaments, allowing crews to resume peacetime endeavors. In October 1865, the *General Banks* was converted back to the steamboat *Creole*, which brought back steamboat service along the Coast.

Most important, survey crews arrived on the Coast in 1867 for a future railroad line from New Orleans to Mobile. The area's postwar economic recovery would ride the rails and sail the waters of the Mississippi Gulf Coast.

By 1869, white and black men worked side by side to lay the rails and build bridges for the New Orleans, Mobile, and Chattanooga Railroad. The lumber mills of the Coast prospered as they provided material for bridges that spanned Chef Menteur Pass, Bay St. Louis, Biloxi Bay, and Pascagoula Bay.

In 1870, the Fourth Military District was no more, as Federals troops left their occupation of the Coast and Mississippi's congressional representation in Washington resumed.

On October 29, 1870, a gold and silver spike was driven into rails at Chef Menteur Pass. The next day, railroad service ran the 139 miles between New Orleans and Mobile, greatly enhancing the economy of the Coast. ■

Gulfport

Gulfport was conceived by William Harris Hardy as a pencil mark on a map . . . surveying a railroad he was building.
—HENRY W. BLACK

Gulfport owes its existence to two men of different backgrounds. One was a Confederate soldier, and the other was a Union soldier. Together, the dreams of one and determination of the other helped form the second largest city in Mississippi.

William Harris Hardy was originally from Lowndes County, Alabama, but his greatest accomplishment would always be tied to Mississippi. During the Civil War, Hardy raised and was elected captain of Company H, Sixteenth Mississippi Regiment.

Hardy and the Sixteenth Mississippi saw action at First Manassas, Stonewall Jackson's Valley Campaign, and Antietam. Suffering from bad health, Hardy resigned after Antietam.

In 1863, Hardy returned to service and was assigned aide-de-camp to Brigadier General James A. Smith. He participated in the defense of Atlanta and the battle of Nashville before Smith's division surrendered in North Carolina in April 1865.

After the war, Hardy returned to Mississippi, becoming involved in a project to build a railroad from Meridian to New Orleans, which formed the New Orleans and Northeastern Railroad.

William Harris Hardy had the dream that would one day form the town of Gulfport.

While surveying land for the tracks of the railroad, Hardy drew a line on a map from Ship Island harbor to present-day Hattiesburg, Mississippi. He noted that there was a "splendid natural harbor at Ship Island . . . and that the time would come when this harbor would be utilized." The harbor and railroad would be vital to harvest the long-leaf yellow pine that covered south Mississippi.

Prior to the Civil War, the state of Mississippi also realized the importance of the piney woods region and a port. The legislature authorized the formation of a town and building of a harbor and railroad. While a depression would stop the building of the railroad, the town of Mississippi City was built. It was the first incorporated town on the Mississippi Gulf Coast.

In 1854, the legislature approved a charter of the Gulf and Ship Island Company to build a railroad. Construction of the railroad was predicated on a seaport being established on the Gulf Coast. The Civil War and Reconstruction halted any work on the railroad or harbor.

As prosperity returned in 1880, Hardy revived the New Orleans and Northeastern Company. During the same time, he proposed a railroad from the Mississippi Gulf Coast northward to Jackson, Tennessee.

Meanwhile, Hardy founded the city of Hattiesburg, Mississippi, naming it after his wife Hattie, and oversaw the construction of a twenty-one-mile creosote pine trestle across Lake Pontchartrain. Hardy later resigned from the New Orleans and Northeastern Company and was offered the presidency of the Gulf and Ship Island Company.

For the Gulf and Ship Island Railroad to be successful, there had to be a port. Hardy selected an area between Mississippi City and Long Beach to serve as his railroad's terminus. This area was uninhabited swampland that was home to mosquitoes, alligators, raccoons, and other animals.

Hardy's new town got its name from R. H. Henry, an editor for the *Jackson Clarion Ledger*. Henry was a friend of Hardy, and the two were brainstorming potential city names. Hardy told Henry that the new town was to be "the Port on the Gulf." Henry transposed the words, and the city of "Gulfport" was born. In August 1887, stakes were driven in the ground to mark the boundaries of Mississippi's newest town.

Later that same year, work began on the terminus of the Gulf and Ship Island Railroad. Still, Hardy struggled with the harbor. The federal government concluded that the harbor was not worthy of improvement.

By 1892, work on the Gulf and Ship Island Railroad had ceased. The following year, another depression gripped the country. In 1894, the Gulf and Ship Island Railroad went into bankruptcy. Hardy's dream seemed to be unfulfilled and his new town of Gulfport in danger. Hardy needed help. Such help was destined to come from the most unlikely of sources. ■

Joseph T. Jones, a former Union soldier, provided the capital and determination to build the city of Gulfport.

A Determined Man

Away from Gulfport, I feel like a fish out of water.
—JOSEPH T. JONES

Joseph T. Jones has been called the "Yankee Fairy Godfather of Gulfport." Jones, who was born in Philadelphia, Pennsylvania, began an unlikely journey to being forever attached to a town in the Deep South.

At the start of the Civil War, Jones enlisted in Company H, Ninety-First Pennsylvania Regiment. Jones participated in the battles of Fredericksburg, Chancellorsville, and Gettysburg. At Gettysburg, Jones fought at Little Round Top.

During the Wilderness Campaign of 1864, Captain Joseph T. Jones was wounded in both feet during the battle of Cold Harbor. Due to his wounds, he was discharged from service.

In 1865, Jones used $2,500 saved from his army pay to start drilling for oil in Pennsylvania. Initially, he had no luck, earning him the nickname of "Dry Hole" Jones. Refusing to quit, Jones borrowed money, and on the thirteenth attempt, he hit a gusher. Dry Hole was no more, and people referred to him as Captain Jones.

Jones amassed a fortune from his oil interests; yet, he still had a childhood fascination with railroads. Jones confided to a friend, "The two things I most wanted in life were a wife and a railroad." Jones had his chance with the bankrupt Gulf and Ship Island Railroad.

On February 14, 1897, Jones arrived on the Mississippi Gulf Coast. He thoroughly investigated the potential possibilities of Ship Island, Gulfport, and the Gulf and Ship Island Railroad. Jones bought into the potential, seizing the Gulf and Ship Island Railroad from bankruptcy and renewing an attempt for a harbor. He requested another study from Congress for dredging a channel to connect Ship Island to a railroad pier. Once again, the federal government saw only expense and no return from a seaport in Gulfport.

Undeterred, a determined Jones decided to dredge his own channel. He bought the *Cape Charles* and ordered pumping machinery to convert the vessel to a dredge. Jones built his harbor while continuing work on the railroad. On January 24, 1902, a special train arrived in Gulfport from Jackson, traveling on the tracks of the Gulf and Ship Island Railroad. With much fanfare, dignitaries watched as the *Trojan* docked at the new Port of Gulfport. Unknown to those watching, Jones had paid the captain of the *Trojan* one thousand dollars and promised to pay for any damage to his vessel since the federal government would not vouch for the safety of the port. Eventually, the federal government would take over operation and future dredging of the harbor.

Five months later, Jones was honored by state and local dignitaries. He announced his continued commitment to Gulfport. He pledged to build the Great Southern Hotel, a union station, and a block of brick buildings that would include a national bank, a new Gulf and Ship Island Railroad building, and an electric generating plant.

Jones called for the relocation of the county seat of Harrison County to be moved from Mississippi City to Gulfport. He kept his promises. In later years, he even constructed an electric trolley line that ran from Pass Christian to Biloxi.

William Harris Hardy's dream of a port, rail line, and city was greatly enhanced by the determination of Jones. The blending of Hardy's dream with the grit and financing of Jones helped create what is present-day Gulfport.

At a personal cost of $16 million, Jones created Gulfport, a town that was destined to become the second largest city in Mississippi and a tourism and business gateway to the rest of the state.

In December 1916, Jones died at his home in Buffalo, New York. Gulfport remembered its greatest benefactor on December 8, as the city shut down, flags flew at half-mast, and mourners paid their last respects to the Grand Old Man of Gulfport.

In February 1917, Hardy, whose dream led to the founding of Gulfport, died at his Coast home. Two men of different backgrounds were forever linked through the city of Gulfport. ■

Seafood Capital

Like a lot of immigrants, they went from being workers and laborers to being prominent citizens, politicians, lawyers, business owners and doctors, playing important community roles. In the beginning they were the backbone of the seafood industry.
—MURELLA HEBERT POWELL

While Gulfport grew into prominence thanks to timber, the railroad, and the fledgling port, Biloxi's postwar growth was due to the sea and its delicious catch of shrimp and oysters.

At the outbreak of the Civil War, George Dunbar of New Orleans sent his two sons to Europe. While there, they learned French canning methods. They returned to New Orleans after the war, where they used their newfound knowledge to can first fruit and then seafood.

Eventually, Dunbar expanded to the Mississippi Gulf Coast, but not until five men formed a partnership that put Biloxi on the seafood map. In 1880, F. William Elmer, William Gorenflo, John Maycock, Lazaro Lopez, and William Dukate formed the Lopez, Elmer, and Company. By the next year, the five-man partnership was canning seafood on Back Bay.

The partnership eventually split up, and the Dunbars arrived from New Orleans. This only served to produce more canneries on Back Bay, Point Cadet, and Biloxi's front beach.

In 1893, a hurricane destroyed most of the schooner fleet on the Mississippi Gulf Coast. This prompted local boat builders to fashion a schooner best suited for coastal Mississippi waters. This gave birth to the Biloxi schooner, a broad-beam, shallow draft vessel with increased sail power. These schooners, often referred to as "white-winged queens," were perfect for negotiating the waters of the Mississippi Sound. Crews on Biloxi schooners caught shrimp and oysters before bringing them to the canneries on the peninsula.

The Mississippi Gulf Coast served as the melting pot for the rest of the state. As the seafood industry continued to grow, immigrants proved to be a vital part of the Mississippi Gulf Coast's economic engine. In 1890, Bohemians of Polish descent arrived from Baltimore as seasonal workers in the seafood industry. The second wave of immigrants were Slavonians from Austria, Yugoslavia, and Croatia. These immigrant families were destined to become mainstays on the Mississippi Gulf Coast. They had names such as Mavar, Sekul, Marinovich, Rosetti, Barhanovich, Skrmetta, Cvitanovich, Peresich, and Covacevich. In the 1970s, Vietnamese families continued the influx of immigrants to Mississippi's seafood industry as they arrived to work in canneries and fish the gulf waters for shrimp and oysters.

Working in the seafood plants was often a family affair. The lack of child labor laws meant small children frequently worked twelve hours a day, standing in shrimp hulls or oyster shells to their knees. In the 1900s, Lewis Hine, sociologist and photographer, captured dramatic images of immigrant children working in Biloxi canneries instead of going to school. The canneries also created their own style of play. Beginning in 1888, they pitted their best sailors and schooners against each other in a race. The winning prize was one hundred dollars and a keg of beer.

The seafood industry continued to flourish along the Mississippi Gulf Coast. In 1893, Biloxi surpassed Baltimore as the "Seafood Capital of the World." ■

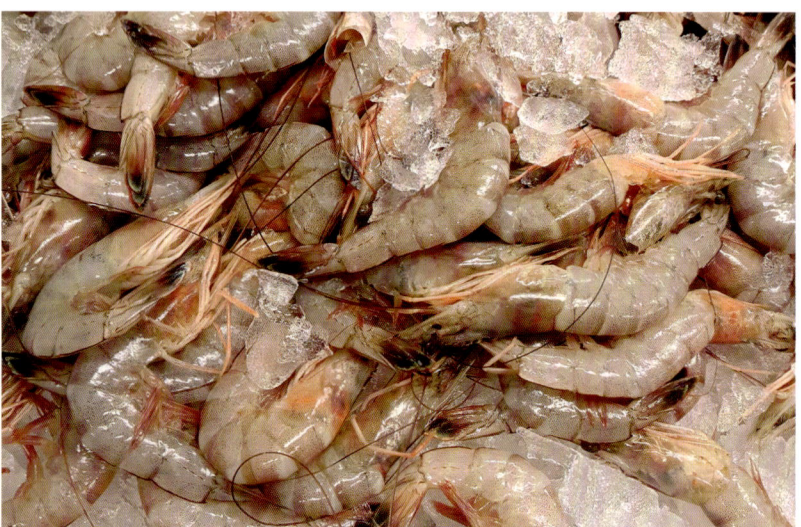

By 1893, Biloxi surpassed Baltimore to become the "Seafood Capital of the World."

"Drink Barq's. It's Good!"

One of my fondest memories was going to Rosetti's Cafe to eat a po'boy called the Vancleave Special and wash it down with an ice cold Barq's Root Beer.
—EDMOND BOUDREAUX

In 1897, Edward Barq moved from New Orleans to Biloxi, Mississippi. The following year, he opened the Biloxi Artesian Bottling Works. The rest is soft drink history.

Born to French parents in New Orleans, Barq lived in France briefly before returning to New Orleans. Upon his return to the Crescent City, he earned a degree in chemistry.

Once in Biloxi, Barq first employed and later became a mentor of Jesse Robinson. By 1900, Barq introduced a new soft drink that is known today as Barq's Root Beer. Two years later, Biloxi Artesian Bottling Works was renamed Barq's Bottling Works.

The Biloxi Artesian Bottling Works was founded by Edward Barq in 1898 on Keller Avenue.

Initially, the popular drink wasn't marketed as root beer to avoid legal issues with the Hires Root Beer company, which was attempting to trademark the term "root beer."

In 1934, Barq and Robinson signed a contract for Barq's product rights that allowed Robinson the freedom to make his own concentrate. Robinson moved to New Orleans, and Barq remained in Biloxi. Barq's was produced in Biloxi and New Orleans. The Biloxi-based Barq's had a logo that was printed in blue, while the New Orleans Barq's was printed in red. In 1935, the slogan "Drink Barq's. It's good" first appeared on the diamond-necked bottles. By 1937, Barq's had sixty-two bottling plants in twenty-two states, primarily in the South. The number grew to two hundred bottling plants by 1950. In 1976, John Koerner and John Oudt bought the company from the Barq family and moved the headquarters to New Orleans. In 1995, Barq's was purchased by the Coca-Cola Company, which expanded the product line to include diet root beer, French Vanilla Creme, Red Creme Soda, and Barq Root Beer Floatz.

The Biloxi Artesian Bottling Works can still be found on Keller Avenue. ■

An Artist's Haven

I am making pots for art sake, God sake, the future generations and—by present indications—for my own satisfaction, but when I'm gone, my work will be prized, honored and cherished.
—**GEORGE OHR**

For more than one hundred years (1870–1993), the Mississippi Gulf Coast served as the birthplace or home for world-renowned artists such as George Ohr, Walter Iglis Anderson, Richmond Barthé, and Dusti Bongé.

Ohr was the first of the Coast artists. Born in 1857 in Biloxi, Ohr was the son of German immigrants. Ohr's father opened the first blacksmith in Biloxi and would also open the town's first grocery.

After the Civil War, Ohr left Biloxi for New Orleans. Once there, Joseph R. Meyer, a childhood friend from Biloxi, offered Ohr a job as an apprentice potter. Ohr knew instantly that he had found his calling, later writing, "When I found the potter's wheel I felt it all over like a wild duck in water."

George Ohr was known as the Mad Potter of Biloxi.

Eventually returning to Biloxi, Ohr opened his own pottery shop. He used natural resources around Biloxi for his pottery, digging clay from the Tchoutacabouffa River. Soon, Ohr was making a name for himself and his pottery. Always the showman, he sported a long, flowing mustache that he often hooked behind his ears. Ohr billed himself as the "Mad Potter of Biloxi."

In 1894, a fire wiped out twenty Coast businesses, including Ohr's pottery shop. Not to be deterred, Ohr rebuilt his business, putting up a five-story tower that resembled a pagoda. He worked tirelessly to restock his pottery.

Ohr excelled in exotic pottery. He claimed that no two pieces were alike. However, fame escaped him. Refusing to sell his pieces at affordable prices, Ohr chose to stop throwing pots and packed up several thousand of them and placed them in storage.

Ohr died of throat cancer in 1918. The fame that had eluded him did not come until 1968, when an antiques dealer from New Jersey bought the whole collection and began to sell them on the market. Now, many consider Ohr the father of the American abstract expressionism movement.

James Richmond Barthé was born in Bay St. Louis, Mississippi, in 1901 and is considered one of the best African American sculptors. He is known for his many public works, including the Toussaint L'Ouverture monument in Port-au-Prince, Haiti, and a sculpture of Rose McClendon for Frank Lloyd Wright's Fallingwater House.

Barthé's artistic ability was apparent at an early age. Since he was black, Barthé could not enroll at any art schools in New Orleans. Through the help of a *Times-Picayune* reporter and Catholic priest, Barthé was enrolled at Art Institute of Chicago. There he excelled as a painter and was introduced to sculpting.

As a sculptor, Barthé garnered well-deserved attention. He received a Guggenheim Fellowship twice, as well as other awards. He sculpted in Jamaica, Switzerland, and the United States (in Harlem and California). He died in 1989.

Walter Inglis Anderson was born in New Orleans in 1903 but made Ocean Springs, Mississippi, his adopted hometown. For most of his life, Anderson earned a living by working at Shearwater Pottery in Ocean Springs, which belonged to his brother, Peter Anderson.

Walter Anderson would decorate the pots that his brother made. When he wasn't doing that, he was often piloting a rowboat to nearby Horn Island, where he drew sketches of the wildlife and scenes of the island. Anderson's mural at the Ocean Springs Community Center is considered one of his masterpieces. After Anderson's death in 1965 from lung cancer, family members discovered a stockpile of Anderson artwork in his Shearwater cottage. Today, Anderson is considered one of the nation's finest artists.

Born in 1903 in Biloxi, Eunice Lyle Swetman, better known as Dusti Bongé, was attracted to the arts at a young age. The stage was Bongé's first love as she directed and starred in childhood productions. She studied acting in Chicago where she met her future husband, Arch Bongé, and got her nickname: friends called her "Dusty" because she was always cleaning her face.

Bongé also excelled as a painter. She and Arch moved to Biloxi, choosing to raise their daughter in the South rather than New York City. Once in Biloxi, they built a studio where both painted. Dusti Bongé died in 1993.

Whether painters, sculptors or photographers, the Mississippi Gulf Coast continues to be a haven for artists. ■

"Laissez Les Bon Temps Rouler"

When people come here, they are just blown away by the fact Mardi Gras exists outside of New Orleans.
—JANE BYRNE

At the turn of a new century, the Mississippi Gulf Coast continued to grow in size and culture. On March 4, 1908, the Coast joined New Orleans and Mobile in celebrating Mardi Gras, a custom brought to America by Iberville and Bienville. On March 3, 1699, the Le Moyne brothers celebrated the French custom by naming Pointe du Mardi Gras, located sixty miles downriver from the area that would become New Orleans.

The Mississippi Gulf Coast joined the Mardi Gras celebration in 1908.

Approximately 209 years later, the Gulf Coast Carnival Association held Biloxi's first Mardi Gras parade, which included 17 floats, 150 flambeau carriers, the new 12-piece *Biloxi Herald* band, a grand marshal, the mayor, and the councilmen. Royalty included the first King d'Iberville and Queen Ixolib. Marching bands, floats, and horseback riders joined in the festivities. The Mardi Gras celebration would eventually spread to every Coast town.

Today, towns and organizations host numerous parades, and "Laissez les bon temps rouler" and "Throw me something, mister" can be heard across the three coastal counties. The Mardi Gras season is a major tourism draw for the area. ■

Ship Builders and Saw Mills

Build me straight, O worthy Master! Stanch and strong, a goodly vessel,
That shall laugh at all disaster; And with wave and whirlwind wrestle!
—HENRY WADSWORTH LONGFELLOW

The onset of World War I brought forth a Coast industry just as another was weakening. Locally, the "War to end all wars" benefited Pascagoula and Moss Point since the area was selected to be a shipbuilding center. The population of the towns quadrupled as shipyards were tasked with building thirty-four military supply ships. However, once the armistice was signed to end the war, the Coast industrial boom of the early 1900s came to a close. Workers left, and ship skeletons were left in their dry docks in various stages of completion.

The Great Depression proved horrendous for Coast tourism and the lumber industry. In 1938, the Dantzler Moss Point Mill shut down, ending a century of lumber manufacturing on the Pascagoula River. Adjusting to the changing times, the mill used byproducts of the mill and became part of the International Paper Company.

Also in 1938, Robert Ingersol Ingalls began improvements to the former World War I shipbuilding location in East Pascagoula. Two years later, Ingalls launched its first ship, the *Exchequer*.

Ingalls went on to produce almost one hundred vessels for the Allies in World War II. During the 1960s and the Vietnam War, Ingalls would expand to the west bank at Pascagoula to bring about the "Shipyard of the Future." ■

Military Installations

The soldier is the Army. No army is better than its soldiers. The soldier is also a citizen. In fact, the highest obligation and privilege of citizenship is that of bearing arms for one's country.
—GEORGE S. PATTON JR.

Also in 1938, President Franklin Roosevelt issued orders to expand the United States Army Air Corps with bases and aircraft. Biloxi, whose economy was tied to seasonal tourism, wanted the year-round economic boost from a military base. Therefore, city officials made the government an offer they couldn't refuse. They offered an 832-acre site located next to the Veterans Hospital on Back Bay. This location already had an airport, a country club, and three golf courses. The government signed a $10 million construction contract to build the base.

The new base was named after Samuel Reeves Keesler, a Greenwood, Mississippi, native. During World War I, Keesler had engaged four German Fokkers in a dogfight and managed to shoot one down before the other German pilots killed him.

After the Japanese attack on Pearl Harbor, Keesler served as a training facility for a half million soldiers who served during the war. Among those training at Keesler were the Tuskegee Airmen.

In Gulfport, the navy picked a 1,150-acre site west of Gulfport to serve as the Naval Mobile Construction Battalion. According to Seabee founder Admiral Ben Moreell, a Seabee was a "soldier in a sailor's uniform, with marine training and doing civilian work at WPA wages."

The Coast has its share of military installations with the Naval Mobile Construction Battalion in Gulfport, Keesler Air Force Base in Biloxi, and Navy Seals Special Boat Team at Stennis Space Center.

In Hancock County, the John C. Stennis Space Center is also home to the Navy Seals' Special Boat Team 22.

Keesler is now home to the Hurricane Hunters, which tracks dangerous storms in the Gulf of Mexico, and the 403rd Wing's 53rd Weather Reconnaissance Squadron, which is responsible for all weather reconnaissance missions flown with the Department of Defense.

The service men and women at all Coast military installations have become the area's best neighbors, often serving as valued members of the Coast community. ■

The Wade-In and Civil Rights

The gifts of God should be enjoyed by all citizens in Mississippi.
—MEDGAR EVERS

As the Mississippi Gulf Coast was about to enter the space race with construction of a NASA facility in Hancock County, African Americans along the Coast sought to obtain freedoms that most whites took for granted.

Beginning in 1959, Dr. Gilbert Mason, Felix Dunn, and other Coast civil rights leaders fought for blacks to enjoy the area beaches and waters. Home owners on the north side of US 90 viewed the beach as private property. However, the beaches had been developed by the Army Corps of Engineers using tax money. They were also maintained using tax money, but still blacks were denied the right to use all but a small location in Gulfport.

African Americans faced angry white mobs in an effort to desegregate the beaches of the Mississippi Gulf Coast.

Mason attended meetings and had petitions signed in an effort to convince city leaders to change the laws, but still the beaches remained for whites only. After smaller protests, Mason and Dunn planned a mass wade-in for three locations on April 17, 1960. The wade-in was to be a peaceful protest. If for any reason violence ensued, blacks were not to fight back.

Police had been alerted of the protest in hopes protection would be provided. Instead, law enforcement alerted other white citizens of the protest. Approximately 125 blacks gathered at the beach before they were attacked by angry whites. Just west of the Biloxi Lighthouse, Mason saw a large number of whites on the beach carrying baseball bats, pool cues, pipes, and chains. As law enforcement watched, whites attacked the unarmed black protestors. The *Clarion Ledger* and *Jackson Daily News* referred to the ensuing melee as the "Bloody Wade-In," calling it the worst and bloodiest race riot in Mississippi.

On May 17, 1960, the US Department of Justice sued the city of Biloxi for denying African Americans access to publicly funded beaches.

The bravery displayed by Mason and friends garnered the attention of Medgar Evers, NAACP field secretary for Mississippi. In a letter to Mason, Evers said, "I am anxious to get something going here in Jackson to the point that I'm willing to risk my life itself . . . If we are to receive a beating, let's receive it because we have done something, not because we have done nothing" (Mason).

Another wade-in was planned for June 16, 1963, and Evers was on the Coast helping Mason plan the protest. But Evers was assassinated on June 12. The planned wade-in was postponed so civil rights leaders could attend Evers's funeral. It was held on June 23, with its participants carrying small black flags to honor Evers.

Despite such sacrifice, leaders such as Mason and Dunn continued their efforts to desegregate Coast beaches. And on August 15, 1968, a little over five years after the death of Evers, the beaches of the Mississippi Gulf Coast were opened to all its citizens. ■

The "New Frontier" by Way of Mississippi

My hope is that Stennis will continue to pioneer in the future those advanced propulsion systems that will take us to Mars and beyond.
—FRED HAISE

In 1961, Hancock County was chosen as the location for NASA's moon rocket test facility. The location on the Pearl River at the Louisiana-Mississippi state line was chosen due to its proximity to the New Orleans NASA Michoud Assembly Facility, which builds rockets. These rockets were built and shipped by water to Hancock County. Next, the rockets were tested and shipped to Cape Canaveral for firing.

In order to build the NASA facility, seven hundred families relocated, and the towns of Gainesville, Logtown, Napoleon, Santa Rosa, and Westonia were razed. In a picture of old versus new, mules were used to clear the land for the future space center. Under the guidance of Dr. Wernher Von Braun, work on Mississippi's NASA facility was completed in 1965.

The Space Center has tested rocket engines for the Saturn V, Apollo, and Space Shuttle programs. In 1988, the center was named the John C. Stennis Space Center in honor of Mississippi's long-time senator. It continues to play an important role in the nation's space program. Locals say that "the road to space goes through Mississippi."

In 2012, Infinity Science Center opened at the Mississippi Welcome Center, just south of the entrance to the John C. Stennis Space Center. One of the driving forces behind Infinity was former Apollo astronaut Fred Haise, who was born and raised in Biloxi. He served on numerous NASA missions, including Apollo 13 and Space Shuttle test flights. Infinity, which is a state-of-the-art science center, serves as a gateway to the Mississippi Gulf Coast for visitors approaching from the west. ■

The Mississippi Gulf Coast has been a melting pot of numerous cultures from all over the world.

The Melting Pot's New Arrivals

They feel like they are Vietnamese living in the United States. But generally, I'd say they are happy here.
—PHAN DUC DONG

Between 1961 and 1996, more than 650,000 Vietnamese refugees came to America. Many of them were drawn to Mississippi's subtropical climate, which was similar to their native country. Moreover, many Vietnamese had made their living as fishermen, so they were drawn to the Gulf Coast and its abundant sealife and made it their adopted homeland.

Some fishermen were able to escape Vietnam in their boats, which were loaded down with friends and family. These boat people had to brave rape, murder, and robbery from pirates cruising the Gulf of Thailand, but the lure of freedom was too great.

Initially, some Vietnamese fishermen in the Gulf Coast area of Texas, Louisiana, Mississippi, Alabama, and Florida suffered violence and intimidation from some of the American fishing fleet. However, they weathered the storm of reprisals, seeking havens that were more respectful and receptive than others.

As the situation continued to deteriorate in the Far East, Vietnamese began to relocate to Mississippi. Between 1980 and 1990, the Vietnamese population in Mississippi more than doubled, and by 2010, the census climbed to 7,025. Now most of Mississippi's Vietnamese citizens live in metropolitan areas, with the largest population in Hancock, Harrison, and Jackson Counties.

Along the Coast, Vietnamese have assimilated into American life. While the older generation still cling to customs from their homeland, younger generations have also adopted the customs and fads of other American youth.

Faith plays an important role for Coast Vietnamese. At Biloxi's East End and Point, Vietnamese homes, businesses, and places of worship dot the landscape that previously served immigrants from eastern European countries. The Vietnamese have their own Buddhist temple and Catholic Church, which are weekly worship spots as well as gathering places for celebrations such as Moon Festival and Tet. ■

Nature's Fury

I think it will be a long time before our beloved Gulf Coast is back. We'll rebuild, smaller and maybe better, as we reach into ourselves and find what truly makes us happy . . . The sunsets are still awesome, as is the sunrise. We can go on because we still have the good things that a storm named Katrina can't take from us.
—MENDY MAYFIELD, *Katrina: Mississippi Women Remember*

Since 1699, hurricanes have been the great equalizer. Whether it is the storms of 1722, 1860, 1893, 1915, 1947, or the named storms like Betsy, Camille, Elena, Georges, and Katrina, hurricanes and their aftermath are a way of life along the Coast.

The Coast has had its share of bad weather with Hurricanes Betsy, Camille, Elena, Georges, and Katrina.

In recent history, Hurricane Camille in 1969 and Hurricane Katrina in 2005 wrought so much destruction that many questioned whether the Coast could survive or rebuild. References to them still cause the most grizzled storm veteran to shudder.

Camille came ashore on August 19, 1969, with a storm surge of twenty-five feet over the seawall in Pass Christian and twenty feet in Biloxi. Top wind speeds were never determined due to the gauges breaking, with the last reported at 230 miles per hour.

A combination of surge and wind pummeled the Coast. There were more than eighty tornadoes contained within Camille. The death toll was 144 people killed and more than 9,000 injured. Almost every building on the Coast received some damage from Camille.

For years, Hurricane Camille was the benchmark for storms along the Mississippi Gulf Coast. Veterans remembered how far her floodwaters reached and what withstood her powerful winds. Any future growth along the Coast was done with Camille's past damage in mind.

Little did Coast residents know that there was a storm even worse than Camille. That storm was Hurricane Katrina, which hit on August 29, 2005, with landfall near the Mississippi-Louisiana border. The eye wall passed over Waveland and Bay St. Louis as a category 3 storm with 120-mile sustained winds. The powerful right-front quadrant of the storm passed over the central Mississippi Gulf Coast. Katrina had a storm surge of twenty-seven feet, which swept six miles inland and twelve miles along area rivers and bays. Major bridges along US 90 at Biloxi–Ocean Springs and Bay St. Louis–Waveland were totally destroyed, and bridges north of the coastline were also damaged. Katrina isolated Coast residents from the rest of the world, leaving many victims without homes, power, food, or water.

In Mississippi, Katrina left 238 dead, 67 missing, and billions of dollars of damage. The three coastal counties of Hancock, Harrison, and Jackson were severely damaged, and all eighty-two counties in Mississippi were declared disaster areas.

Like Camille before her, Katrina became the benchmark for Mississippi Gulf Coast storms. Coast residents pray there isn't a storm lurking that is more devastating than Katrina. ■

A Roll of the Dice

The other social aspect we're very proud of is giving back to the community. It would be safe to say that casinos are one of the largest donors to charities on the Gulf Coast.
—**LARRY GREGORY**

After Hurricane Camille, the Mississippi Gulf Coast economy stagnated for decades. A new influx was needed to jump-start the economy while also paving the way to a brighter future. For Coast residents, that new business was casino gaming.

On June 29, 1990, the Mississippi legislature passed the Mississippi Gaming Control Act. It allowed local residents to decide whether gaming could be located in their town. The act also stipulated that no gambling be permitted on Mississippi soil but only on vessels docked along the shoreline of the counties on the Mississippi Sound or along the Mississippi River.

On December 5, 1990, gaming was approved in Hancock County but not in Harrison or Jackson Counties. It wasn't until March 10, 1992, that Harrison County approved having casinos.

Five months later, the Isle of Capri opened near Point Cadet in Biloxi. Many of the fledgling casinos were located where canneries once stood as one Coast industry gave way to another. Casino gaming became the next economic boon for the Coast as more elaborate establishments were built. In 2005, Hurricane Katrina severely damaged the Coast casino industry, and an early provision of dockside only was put to a test.

The Mississippi legislature decided to allow Coast casinos to move north of US 90 instead of mandating they be dockside on water. Such a move helped to insure a safer environment and a better chance for less structural damage from hurricanes.

Casino gaming is now one of the economic engines that provides a steady nest egg for the state treasury. ■

Signs denote the future location of the Mississippi Aquarium in Gulfport. The aquarium is slated to open in 2019.

A Bright Future

If life gives you limes, make margaritas.
—JIMMY BUFFETT

Having survived devastating hurricanes, the BP oil spill, and the 2008 economic collapse, Coast residents are hoping for better days and a brighter future. It has taken time, but museums of art and history are now opening in Biloxi, Gulfport, Ocean Springs, and Hancock County. In Gulfport, Ocean Springs, and Bay St. Louis (which has a more art-oriented crowd), the downtown areas have become trendy restaurant districts.

As new casinos have opened and other tourism venues are on the horizon, established gaming locations are adding to or improving their existing properties.

The area is blessed with a natural beauty that continues to draw visitors from around the globe. The beach is still the beach, and it continues to be a steady draw for those just wanting to walk in the sand, wade in the gulf waters, and relax in a tropical setting.

New businesses are slowly returning to the area, and there is always talk of more family attractions for an area that relies on tourism dollars. In 2016, the city of Gulfport announced ambitious plans to build the Mississippi Aquarium on land that has been vacant since Hurricane Katrina destroyed structures a decade ago. The aquarium will be in downtown Gulfport, facing Jones Park and the Mississippi Sound to the south. Slated to be completed in 2019, the Mississippi Aquarium promises to be a family-oriented destination to go along with the beach, art museums, historic locations and casinos.

Through it all, the Coast continues to reinvent itself while holding onto its storied past. ∎

Welcome to BAY SAINT LOUIS

- PASS CHRISTIAN
- LONG BEACH
- GULFPORT
- D'IBERVILLE
- BILOXI
- OCEAN SPRINGS
- PASCAGOULA

GULF OF MEXICO

Sunrise fisherman

Cedar Rest Cemetery

GROUND ZERO MUSEUM The Waveland Civic Center (the Old Waveland School circa 1927) serves as the focal point of the ongoing recovery effort from Hurricane Katrina. Half of the Civic Center was destroyed by Katrina's eleven-foot storm surge. On the ninth anniversary of that deadly storm, the Ground Zero Hurricane Museum was opened in the building. On August 29, 2005, Hurricane Katrina came ashore west of Waveland. The town was almost wiped off the map, as homes and businesses were destroyed. The museum features framed front pages of local papers dealing with Hurricane Katrina and a tattered flag that flew over Waveland during the storm. Outside, there are a Hurricane Camille memorial and two monuments for Katrina.

Jean-Baptiste Le Moyne de Bienville Statue

Bay St. Louis

220 Main Street Gallery

ST. ROSE DE LIMA CATHOLIC CHURCH In the years following the Civil War, missionaries moved to the South in an effort to educate former slaves. In the early 1900s, missionaries opened schools in an effort to continue their work. In 1926, St. Rose de Lima Catholic Church was opened. The church was located across the street from the school with the same name, which had been completed a year earlier. The school bell can now be found on the grounds of St. Rose de Lima Catholic Church. The school remained open until integration began in Mississippi, when it joined with Our Lady of the Gulf to become Bay Catholic Elementary. In 1991, during a church renovation, a mural was painted in the sanctuary, depicting a Christlike figure, free of all earthly bonds, floating in front of a massive Spanish oak tree representing the Cross. The mural is a signature piece of artwork in the now multiracial Catholic church.

Cloud reflection, Waveland, Mississippi

Bay Town Inn

St. Augustine grotto

ST. AUGUSTINE SEMINARY Opened in 1923, the St. Augustine Seminary was established by the Society of the Divine Word. The seminary was the only place where African American men could study for the priesthood. Father Matthew Christman served as the first rector. Christman's strong leadership and principles helped guide the seminary and its graduates through turbulent racial times. Christman called it "a grave injustice to exclude a whole race from the priesthood," and he championed the cause of St. Augustine graduates. St. Augustine's first graduates were ordained in 1934. The seminary remained open until 1967. Today, the seminary is a retreat center for the Society of the Divine Word Southern Province.

100 MEN D.B.A. HALL served as the center of the African American social scene in Bay St. Louis. The 100 Men Debating Benevolent Association was formed in 1894 to "assist its members when sick, bury its dead in a respectable manner and knit friendship." From the 1940s to the 1960s, the 100 Men Hall hosted some of the biggest names in blues and soul music performing on the "chitlin' circuit," including Big Joe Turner, Etta James, Guitar Slim, and James Booker. In 2005, the building was rescued from demolition following Hurricane Katrina by Jesse and Kerrie Loya, who restored the hall to its original state through a grant from the Mississippi Department of Archives and History.

MISSISSIPPI BLUES COMMISSION EST 2003

100 MEN D.B.A. HALL

The 100 Men D.B.A. Hall, a longtime center of African-American social life

Bay St. Louis

Hancock Bank

INFINITY SCIENCE CENTER On April 11, 2012, the Infinity Science Center opened its doors. It was on that date in 1970 that *Apollo 13*, carrying Biloxi's Fred Haise, launched into space. Haise was slated to become the sixth man to walk on the moon and pilot the lunar rover. Instead, a malfunction threatened the lives of astronauts Haise, Jim Lovell, and John Swigert. Haise now serves as Infinity Board vice chairman, working to bring the best possible science center to his native Mississippi Gulf Coast. The Infinity site was selected near the Mississippi Welcome Center in Hancock County. It replaces StenniSphere, which was located at the John C. Stennis Space Center. Infinity features exhibits celebrating America's space program as well as scientific achievements that helped bring it about. Outside of the facility, a Marlin Miller statue of an eagle, carved using a tree and material from NASA tests, stands at Stennis and Space Shuttle rocket engines.

40 Bay St. Louis

Shoo Fly

BRETT LORENZO FAVRE started his playing career on the Mississippi Gulf Coast and would eventually end up in the NFL Hall of Fame. Favre played for his father, Irvin Favre, at Hancock North Central High School. From there, he reached legendary status with his exploits for the Southern Miss Golden Eagles. Drafted by the Atlanta Falcons, he was traded to the Green Bay Packers a year later. Favre became an NFL icon with the Packers, leading Green Bay to two Super Bowl appearances with one victory. In the later part of his career, Favre also played for the New York Jets and Minnesota Vikings. He was inducted into the NFL Hall of Fame in 2016. The Coast still remembers Favre with a statue, a field named in his honor, and welcome signs at Kiln, Mississippi, otherwise known as "the Kill."

Pass Christian
Founded 1699

BAY ST. LOUIS · LONG BEACH · GULFPORT · BILOXI · D'IBERVILLE · OCEAN SPRINGS · PASCAGOULA

GULF OF MEXICO

Bald eagle

Penthouse Pier

War Memorial Park

The Blue Rose

48 Pass Christian

St. Paul Chapel

Oak trees and scenic drive swing

Neon fish

Dixie White House

Pass Christian Books

Boys and Girls Club

Pass Christian

Boat and approaching storm

Sunset stroll

Long Beach

GULF OF MEXICO

BAY ST. LOUIS · PASS CHRISTIAN · GULFPORT · D'IBERVILLE · BILOXI · OCEAN SPRINGS · PASCAGOULA

Cast netter

Long Beach 59

Simpson Pier and rainbow

THE UNIVERSITY OF SOUTHERN MISSISSIPPI GULF PARK CAMPUS In 1919, J. C. Hardy founded the Gulf Park College for Women. Gulf Park graduated its last class in 1971. The following year, the campus reopened as the Gulf Park campus of the University of Southern Mississippi (USM). The campus provided upper-level course work for bachelor and graduate degrees. In 2002, the Southern Miss Gulf Park campus admitted freshmen, making USM a dual campus university. The Gulf Park campus survived significant damage from Hurricanes Camille and Katrina. Gulf Park continues to grow and serve the Mississippi Gulf Coast and has become an important part of the Coast. In 2016, a new gateway to the Southern Miss Gulf Park campus was built, showing more is yet to come. Southern Miss also has locations at Stennis Space Center and at Gulf Coast Research Lab in Ocean Springs.

Darwells

Friendship Oak

Gulfport
MISSISSIPPI

Barksdale Pavilion

Port of Gulfport

68 Gulfport

Grazing horses

Lynn Meadows Discovery Center

Gulf Islander and marina

Martin Luther King Jr. and Barack Obama

Dolphin at Institute of Marine Mammal Studies

Jones Park Lighthouse

TRIPLETT - DAY DRUGS A staple on the Mississippi Gulf Coast since 1955, Triplett-Day is more than just a locally owned drug store but a treasured nostalgic trip to yesteryear. Other than getting prescriptions filled, Triplett-Day offers 1950s-style old-fashioned soda and milk shakes. Triplett-Day also serves breakfast and lunch daily. Their meals are a favorite of locals and tourists stopping by for the first time. Breakfast features Triplett-Day's famous homemade biscuits and beignets. The *Food Network Magazine* recently named Triplett-Day beignets as the Tastiest Breakfast in Mississippi. Aside from the food, Triplett-Day breakfast also includes coffee and a rousing conversation from locals, who make the breakfast location the place to be to discuss sports, politics or any other topic that might come up.

Island View Casino Beach Tower

Dawn and Jones Park Anchor

FORT MASSACHUSETTS In 1833, Jefferson Davis was a candidate for the US House of Representatives. Part of Davis's platform was building a lighthouse and fort on Ship Island. The lighthouse was built twenty years later. It wasn't until Davis was Secretary of War that construction began on the fort in 1859. Construction stopped two years later as the nation plunged into Civil War. Initially, the island was held by Confederate soldiers but was occupied by Union soldiers from the fall of 1861 to 1865. Union soldiers continued to build the fort which they named Fort Massachusetts after their flagship. Throughout the war, work continued on the fort. In 1866, construction was almost complete when work on the fort ended. It was turned over to a civilian keeper to keep the fort in readiness.

FISHBONE ALLEY Patterned after Printer's Alley in Nashville, Fishbone Alley has become one of Gulfport's most popular night spots while garnering attention for innovation and creativity. Fishbone Alley opened October 3, 2016. It was a dank area that was turned into a cultural haven for musicians, artists, and those seeking an active night life. There patrons can go from one restaurant or bar to another in a lighted alley that is covered with work from local artists. Musicians also use the alley as a place to perform. The Mississippi Main Street Association gave Fishbone Alley the Innovation on Main Street award, and the *New York Post* called it one of "8 amazing American streets you've never heard of." The *Post*'s website said, "On this unassuming backstreet, live blues music brings bold graffiti art to life."

Black skimmer

Sunrise solitude

BILOXI

- D'IBERVILLE
- OCEAN SPRINGS
- PASCAGOULA
- GULFPORT
- LONG BEACH
- PASS CHRISTIAN
- BAY ST. LOUIS

GULF OF MEXICO

Big Lake · Biloxi Bay · Pascagoula Bay

Town green

Lightning burst

Seafood and Maritime Museum

Lighthouse sunrise

City Hall

HURRICANE CAMILLE MEMORIAL

DECEASED

Granville H. Alexander
Granville "Jack" Alexander
Huey J. Alexander
Mary Alexander
Karl S. Axtater
Fanny Alice Brown Bagg
Hannah Levy Barker
Leonard Barnes
Arden Mary Barrett
Charlotte Joan Barrett
Victoria Arlene Barrett
Janet Bellehumer
Amelia Benoit
Deborah Hewes Berry
Renee L. Bettencourt
Theresa A. Bettencourt
Elizabeth Bishop
William Harold Bloodworth

Merland John Boyer
Florence Brown
George Brown
Myron F. Bundy
Bridget Burton
Myrtle Mae Burton
Tom Charmichael
Catherine Chauvin
Christine Marie Chauvin
Diedra Lenell Chauvin
James Matthew Chauvin
Teresa Wanda Chauvin
Maude Colbet
Cynthia Cornell
William Howard Covington
Anna Dambrink
Elizabeth Dambrink
John Dambrink, Sr.
Aline Daniels

Bonnie Holcomb Demetz
Arthur Dykes
Mary Eaton
Julia McDonald Everett
Edward Mortenson Farmer
James Beryl Farmer
Fred E. Gerlanch, Jr.
Shirley Ann Geshke
Mamie Johnson Gianelloni
James J. Gilbert
Marie Joullian Gilbert
Andrew Green
D. L. Griffin
Frances G. Halat
Jerry Hall
Helen Vincent Hardin
Helen Iva Mae Holifield
Vera Pearl Holifield
Margaret L. Hollins

Emma Lyons Hosch
Bessie Sigsworth John
William Henry John
Charles Douglas Jones
Helen Freebold Jones
Merwin J. Jones
Phoebe L. Jones
George Henry Kamlade
Frances Eleanor Kassum
Luane Marie Keller
Elsa Logan
Annabelle Majorie Luttge
Francis Anne Magee
Stacy Diana Magee
Jack Ford Matthews
Clare Bancroft Mayer
Olive Whitehead Huitt McBryde
Hugh J. McDonald
Violet McDonald

Lamont Mitchell
Roy Michael Moffett
Anneas Saadi Moses
Elmer Lawrence Nelson
Emmett S. Robinson, Jr.
Jessie Lucinda Nelson
Nyme Joseph Newman
Willie James Norman
Erwin Harrison Oelke
Evelyn Jeanette Oelke
Ramey Oelke
Rebecca Oelke
Gilbert O'Neill
Genevieve Newman Owen
Sam Owen
John Henry Palmer
Roosevelt Palmer
Hattie Bell Plummer
Emile Prager
Irene McCollum Prager

Peter John Rabito
Joseph Carl Rich, Sr.
Nellie Naomi Rich
Emmett S. Robinson, Jr.
Virgil Fred Rose
Arthur P. St. Onge
Fannie Elizabeth Savage
Charlotte Ruth Schustedt
Fred Nathaniel Schuyten
Andrew Hartwig Schuyten, Jr.
Andrew Hartwig Schuyten, Sr.
Kathleen Rivers Simmons
George Robert Smith, Jr.
Helen Elizabeth Smith
Margaret Rose Smith
Mary Belle Mabry Smith
Willie Stallworth
Selma Faye Sykes
Cornelius E. Talbert

Maris Stella Tucei
Alvin G. Wagner
Leone Welch
Anna W. Williams
Charles D. Williams
Clara Mae Williams
Deborah Williams
Eddie K. Williams
Esther L. Williams
Floyd Williams
Jeremiah M. Williams
Myrtle M. Williams
Sylvester Williams
John Walter Williams
Sheldon T. Wozniak

UNKNOWN

FAITH
HOPE
CHARITY

MISSING

E.W. Bielar
Mrs. Byrd
Billie Caroll Carter
Robert Carter
John Cartwright

Hurricane Camille Memorial

BILOXI SCHOONERS Characterized by a broad beam, shallow draft, and increased sail power, the Biloxi schooner became a vital part of the seafood fleet. From the late 1800s to the early 1900s, the schooners navigated the shallow waters along the Mississippi Gulf Coast but could also handle deeper seas. The large decks allowed room for crews to work, and large sails allowed the schooner to pull shrimp seines and oyster dredges. Referred to as "White-Winged Queens," the schooners were equally graceful and ideal for working waters around the Mississippi Sound. The Biloxi Maritime and Seafood Industry Museum operates two replica schooners. The *Glenn Swetman* was built by William Holland and the *Mike Sekul*, by Neil Covacevich. The museum uses these schooners for charters and education programs. They can be found at the Biloxi Schooner Pier Complex on US 90.

94 Biloxi

MGM Park

Kayakers

PLEASANT REED HOUSE Born into slavery, Pleasant Reed left John B. Reed's plantation near Hattiesburg for the Mississippi Gulf Coast. In 1884, Reed and Georgia Anna Harris were married. The Reeds enjoyed some freedom during Reconstruction only to suffer through segregation during the Jim Crow era. Throughout it all, Reed persevered, earning money as a carpenter and jack-of-all-trades, and making shrimp nets for area fishermen. In 1887, Reed began construction of his home on Elmer Street. Other families of different ethnic backgrounds also built homes, making it a multiracial neighborhood. The Pleasant Reed Interpretive Center is a reconstruction of the original house built by Reed in the late nineteenth century. The house offers a glimpse at how African Americans lived in Biloxi during the twentieth century. The original house was destroyed by Hurricane Katrina in 2005.

Shrimp fleet

Interstate 110 loop

Chua Van Duc Buddhist Temple

Beauvoir

Hurricane Katrina memorial

Pierre Le Moyne Sieur d'Iberville

THE BATTLE IS OVER REST IN PEACE

BILOXI NATIONAL CEMETERY Encompassing fifty-four acres at the Veterans Affairs Medical Center, the Biloxi National Cemetery offers a final resting place under the shade of live oak trees. The cemetery was established in 1934, and its first burial was March 24, 1934. From 1934 to 1973, the cemetery's main purpose was to provide a final resting place for veterans who died at the adjoining medical center. In 1973, the National Cemetery Act passed, allowing the grounds to be open to all honorably discharged veterans, active duty personnel, and their dependents regardless of where they died. The cemetery began with twenty-five acres and has doubled in size. Notable burials at the cemetery include Colonel Ira Welborn, a Congressional Medal of Honor recipient for actions in the Spanish American War.

Ohr-O'Keefe Museum of Art

Sharkheads souvenirs

Sand castle

Mardi Gras Museum

Mary Mahoney's Old French House

Old Biloxi Cemetery

CASINO NIGHTS Whether billiards, schooner races, cards, or slots, gambling has been a mainstay on the Mississippi Gulf Coast since before the days of the Civil War. Although gaming was popular, others complained about a tawdry and lawless element. While law enforcement began to crack down in the 1950s, gaming still was popular. The industry and Coast tourism were dealt a crushing blow when Hurricane Camille hit in 1969. In 1990, the Mississippi Gaming Control Act was passed allowing for gaming on the Coast and along the Mississippi River. Since then, casinos of all shapes and sizes have been built, bringing back a historically significant return to life on the Coast. Casinos such as the Beau Rivage, Hard Rock, Golden Nugget, IP, Boomtown, Harrah's, and the Palace have become mainstays in Biloxi.

Beau Rivage and MGM Park

Crawfish Festival

Fishin' up a storm, Point Cadet

Fire hose nozzles, Biloxi Fire Museum

BILOXI FIRE MUSEUM Located in a 1937 fire house, the museum has photographs, uniforms, and equipment that date back more than 120 years and document the history of the Biloxi Fire Department. The museum is dedicated to all Biloxi firefighters and particularly those who gave their last full measure.

Biloxi Bay Bridge

Biloxi **121**

Weeping angel, Moran Site

City of D'Iberville
Founded 1988

Bay St. Louis · Pass Christian · Long Beach · Gulfport · Biloxi · Ocean Springs · Pascagoula

Gulf of Mexico

Town clock

Scarlet Pearl

OCEAN SPRINGS

Walter Anderson Museum of Art

Inner harbor

VIETNAM VETERANS MEMORIAL In 1985, the idea of a Mississippi Vietnam Veterans Memorial was born. The priority was to honor native sons who served in a war that ran from 1958 through 1975. On May 31, 1997, the idea became a reality as the Magnolia State's Vietnam Veterans Memorial was unveiled in Ocean Springs. The memorial features the names of Mississippi's fallen heroes. It also has more than six hundred laser-etched photographs of these heroes who gave their last full measure of devotion. Since its unveiling, more monuments have been placed around the Vietnam Memorial, including a Vietnam-era Huey helicopter, the mast of the *Mississippi*, and a monument to submarine crews. There is also a walking track that features plaques of Mississippi Medal of Honor recipients.

Alligator at Davis Bayou

DAVIS BAYOU Serving as part of the Gulf Islands National Seashore, Davis Bayou is located in Ocean Springs. The bayou allows visitors the opportunity to get closer to nature. They can enjoy fishing, hiking, camping, bird watching, or participating in Ranger-led programs. A walk along Davis Bayou offers scenic vistas to watch the sunset or observation decks to see alligators, egrets, herons, eagles, and other wildlife indigenous to the area. Davis Bayou is a great place to picnic, host reunions, or play baseball under majestic live oaks. It is a camping destination that offers slips to cast canoes or kayaks.

Harbor dawn

Depot

OCEAN SPRINGS COMMUNITY CENTER MURAL In 1951, Walter Anderson began work on a twenty-five-hundred-square-foot mural depicting the different seasons, the Native American culture, and the landing of French explorers in 1699. At that time, Anderson's genius wasn't fully appreciated, as some locals openly ridiculed his work. To escape the comments, Anderson worked on the mural late at night. Anderson was paid one dollar for painting the mural. Today, the mural is valued at more than $30 million.

Bridge and mosaic

Ocean Springs 139

Fort Bayou reflection

THE CITY of Pascagoula
MISSISSIPPI's FLAGSHIP CITY

BAY ST. LOUIS • PASS CHRISTIAN • LONG BEACH • GULFPORT • D'IBERVILLE • BILOXI • OCEAN SPRINGS

GULF OF MEXICO

Pascagoula River, Escatawpa, Mississippi

Ingalls Shipbuilding

PASCAGOULA RIVER AUDUBON CENTER In 1974, more than thirty-five thousand acres of land along the Pascagoula River were preserved for the public. Due to the efforts of the Nature Conservancy, this preserved space helps protect the ecosystem along the Pascagoula River, the largest free-flowing river in the contiguous United States. The Pascagoula River Audubon Center serves as the gateway to the Pascagoula River and the wildlife indigenous to the area.

Pascagoula

Jimmy Buffett Bridge

Grand Magnolia

Longfellow House

Round Island Lighthouse

River Boardwalk, Moss Point, Mississippi

Veterans Tower, Gautier, Mississippi

The Old Place, Gautier, Mississippi

Escatawpa River shrimp boat, Moss Point, Mississippi

Coast Traditions

Coast Traditions 157

Beginning in 1996, Cruisin' the Coast was a week-long event that celebrated classic cars and music. During the first year, more than three hundred cars were registered. The event has grown each year, to more than seven thousand cars registering for Cruisin'. With events in each Coast town, Cruisin' the Coast is a favorite coastwide experience. Vintage cars now cruise Coast streets for what has become a popular block party.

The seafood industry helped to create the town of Biloxi. Prior to the seafood boom, Biloxi was a small resort town. Local businessmen opened seafood processing plants, which led to a large influx of immigrant workers. Serving as Mississippi's melting pot, Slavonians, Cajuns, and Vietnamese migrated to Biloxi. At first, they worked in the canning plants but eventually bought their own boats, becoming shrimpers who caught and sold their own catch. The Blessing of the Fleet comes from the strong Catholic faith of these immigrants as the seamen and their vessels are blessed before each season. This is a time to decorate one's vessel and pray for a safe and profitable shrimp season.

Carnival season is the perfect time for residents and visitors to celebrate Mardi Gras at multiple parades along the Mississippi Gulf Coast. Shouts of "Throw me something mister" can be heard over blaring music as floats make their way along the parade route. Beads, doubloons, stuffed animals, food items, and other trinkets are tossed from the floats to the outstretched hands of revelers below. Each year the parade theme changes, and Coast residents just let the good times roll.

Coast Traditions 161

Created to honor Peter Anderson, master potter and first potter at Shearwater Pottery, the Peter Anderson Festival is a celebration of the arts. Set in downtown Ocean Springs, it has grown from a modest beginning to become one of the Southeast's premier arts and crafts festivals. Recent festivals have reported record crowds of 120,000 people in attendance and more than four hundred booths.

Whether by land, air, or sea, Coast residents celebrate Christmas in their own unique way. Palm trees, which usually are signs of a tropical climate, are decorated in lights. Boats have as many lights as any Christmas tree. Lighthouses, which serve as beacons to boaters, are decorated with a host of garlands and lights to make a Mississippi Gulf Coast Christmas memorable.

"You don't make a photograph just with a camera. You bring to the act of photography all the pictures you have seen, the books you have read, the music you have heard, the people you have loved."

—ANSEL ADAMS

Fort Bayou Sunrise, Ocean Springs, Mississippi

BIBLIOGRAPHY

Alexander, Mary Ellen. *Rosalie and Radishes: A History of Long Beach, Mississippi*. Gulfport, MS: Dixie, 1980.

Barnwell, Marion, edited. *A Place Called Mississippi: Collected Narratives*. Jackson: University Press of Mississippi, 1997.

Bettersworth, John K. *Mississippi: Yesterday and Today*. Austin: Steck, 1964.

Black, Henry W. *Gulfport: Beginnings and Growth*. Bowling Green: Rivendell, 1986.

Carter, Hodding, and Anthony Ragusin. *Gulf Coast Country*. New York: Duell, Sloan and Pearch, 1951.

Cirlot, F. W. *Historical Sketch of the City of Moss Point, Mississippi*. Avertiser, 1964.

Clark, Garth, Robert Ellison, Jr., and Eugene Hecht. *The Mad Potter of Biloxi: The Art and Life of George E. Ohr*. New York: Abbeville, 1989.

Cox, W. A., and E. F. Martin. *Facts about the Gulf Coast*. Gulfport, 1905.

Crouse, Nellis M. *Lemoyne d'Iberville: Soldier of New France*. Baton Rouge: Louisiana State University Press, 1954.

Cuevas, John. *Cat Island: The History of a Mississippi Gulf Coast Barrier Island*. Jefferson, NC: McFarland, 2011.

Dubay, Robert W. *John Jones Pettus: Mississippi Fire-Eater; His Life and Times*. Jackson: University Press of Mississippi, 1975.

Fraiser, Jim *Vanished Mississippi Gulf Coast*. Gretna, LA: Pelican, 2006.

Fulkerson, H. S. *Recollections of Early Days in Mississippi*. Baton Rouge: Otto Claitor, 1937.

Galloway, Patricia K., editor. *LaSalle and His Legacy: Frenchmen and Indians in the Lower Mississippi Valley*. Jackson: University Press of Mississippi, 1982.

Giraud, Marcel. *The History of French Louisiana: Vol. 1*. Baton Rouge: Louisiana State University Press, 1953.

Golding, Melody, edited by Sally Pfister. *Katrina: Mississippi Women Remember*. Jackson: University Press of Mississippi, 2007.

Greenwell, Dale. *Twelve Flags: Triumphs and Tragedies, Vol. 1*. Self-published, 1968. https://www.amazon.com/Twelve-Flags-Triumphs-Tragedies-1/dp/B002NC6P02.

Hall, Basil. *Travels in North America in the Years 1827–28* (3 vols., Edinburgh, 1829); III, 133.

Hall, James, *A Brief History of the Mississippi Territory*. Spartanburg, SC: Reprint Company, 1976.

Hayden, Julius J., Jr. "The History of Pass Christian, Mississippi." Master's thesis at the University of Southern Mississippi, 1950.

Hickman, Nollie W. *Mississippi Harvest: Lumbering in the Longleaf Pine Belt*. Jackson: University Press of Mississippi, 2009. http://www.upress.state.ms.us/books/1218.

Higginbotham, Jay. *Fort Maurepas: The Birth of Louisiana*. Mobile: Colonial Books, 1968.

———. *Pascagoula: Singing River City*. Mobile: Gil, 1967.

———. *The Pascagoula Indians*. Mobile: Colonial, 1967.

Hodgson, Adam. *Letters from North America*. (2 vols., London, 1824), I, 113–14.

Keating, Bern. *The Gulf of Mexico*. New York: Viking, 1972.

Koch, Kathleen. *Rising from Katrina*. Winston-Salem, NC: John F. Blair, 2010.

Lang, John H. *History of Harrison County*. Gulfport: Dixie, 1936.

Lippert, Ellen J. *George Ohr: Sophisticate and Rube*. Jackson: University Press of Mississippi, 2013.

Mahon, John K. *Indians of the Lower South*. Pensacola Gulf Coast History and Humanities Conference, 1975.

Mason, Gilbert R., and James Patterson Smith. *Beaches, Blood and Ballots: A Black Doctor's Civil Rights Struggle*. Jackson: University Press of Mississippi, 2000.

McEwan, Bonnie G., edited. *Indians of the Greater Southeast*. Gainesville: University Press of Florida, 2000.

McLemore, Richard A. "The Beginnings of Gulfport." A speech given to Gulfport Lions Club, 1971.

———, editor. *A History of Mississippi, Vols. 1 and 2*. Jackson: University Press of Mississippi, 1973.

McWilliams, Richeborg Gaillard, editor and translator. *Fleur de Lys and Calumet: Being the Penicaut Narrative of French Adventure in Louisiana*. Baton Rouge: Louisiana State University Press, 1953.

———. *Iberville's Gulf Journals*. Tuscaloosa: University of Alabama Press, 1981.

Mohr, Richard D. *Pottery, Politics, Art: George Ohr and the Brothers Kirkpatrick*. Urbana and Chicago: University of Illinois Press, 2003.

Moreell, Ben. *The Leatherneck* 46, p. 63.

Oliver, Nola N. *The Gulf Coast of Mississippi*. New York: Hastings House, 1941.

Rainwater, Percy Lee. *Mississippi: Storm Center of Secession 1856–1861*. Baton Rouge: Otto Claitor, 1938.

Rand, Clayton. *Men of Spine in Mississippi*. Gulfport: Dixie, 1940.

Rowland, Mrs. Dunbar. *Mississippi Territory in the War of 1812*. Baltimore: Genealogical, 1968.

Schmidt, C. E. *Ocean Springs: French Beachhead*. Pascagoula: Lewis, 1972.

Schueler, Donald G. *Preserving the Pascagoula*. Jackson: University Press of Mississippi, 1980.

Sheffield, David, and Darnell L. Nicovich. *When Biloxi Was the Seafood Capital of the World*. The City of Biloxi, 1979.

Smith, Mark M. *Camille 1969*. Athens: University Press of Georgia, 2011.

Sugg, Redding S., Jr., editor. *The Horn Island Logs of Walter Inglis Anderson*. Memphis: Memphis State University Press, 1973.

Sullivan, Charles, and Murella Hebert Powell. *The Mississippi Gulf Coast: Portrait of a People*. Brightwaters, NY: Windsor.

Swanton, John R. *Indian Tribes of the Lower Mississippi Valley*. Washington, DC: Government Printing Office.

———. *The Indian Tribes of North America*. Washington: Smithsonian Institution Press, 1952.

Thatcher, George, *Scenes from the Beach*. Brandon, MS: Quail Ridge, 2003.

Usner, Daniel H., Jr. *Indians, Settlers and Slaves in a Frontier Exchange Economy: The Lower Mississippi Valley Before 1783*. Chapel Hill: University of North Carolina Press, 1992.

Weaver, C. P. *The Civil War Diary of Col. Nathan W. Daniels*. Baton Rouge: Louisiana State University Press, 1998.

Williams, Richebourg Gallard, editor. *Pierre Le Moyne d'Iberville: Iberville's Gulf Journals*. Tuscaloosa: University of Alabama Press, 1981.

Woolfolk, Doug, editor. *Seventy-Five Years of Mississippi Coast and Hancock Bank*. Hancock Bank, 1974.

INDEX

A

Achilles (schooner), 10
Allen, H. W., 10
Anderson, Peter, 18, 162
Anderson, Walter Inglis, 17, 18, 128, 136

B

Badine (vessel), 3
Barbour, Haley, 8
Barq, Edward, 16, 17
Barq's Bottling Works, 16
Barthé, Richmond, 17, 18
Bay St. Louis, Mississippi, xi, xiii, xiv, 7, 8, 13, 18, 22, 23, 26
Bay Town Inn, 33
Beau Rivage Casino, 113, 114
Beauvoir, 101
Bienville, Jean-Baptiste Le Moyne Sieur de, 3
Billington, James, 11
Biloxi, Mississippi, xi, xii, xiii, xiv, 1, 2, 3, 4, 5, 6, 7, 8, 9, 10, 12, 13, 14, 15, 16, 17, 18, 19, 20, 21, 22, 23, 38, 93, 96, 105, 111, 113, 117, 119, 158
Biloxi Fire Museum, 117

Biloxi Herald, 19
Biloxi Indians, 1
Biloxi Lighthouse, xiii, 9, 10
Biloxi National Cemetery, 105
Biloxi Rifles, 9, 12
Biloxi Schooners, 16, 93
Black, Henry W., 14
Black Joker (blockade runner), 10
Blessing of the Fleet, 158
Bonaparte, Napoleon, 6
Bond, John, 7
Bongé, Arch, 18
Bongé, Dusti (Eunice Lyle Swetman), 17, 18
Boudreaux, Edmond, 16
Buffett, Jimmy, 23, 146
Butler, Benjamin, 10
Byrne, Jane, 18

C

Canby, E. R. S., 12
Choctaw Indians, 5
Civil War (American), 9

Cruisin' the Coast, 157
CSS *Shenandoah*, 12

D

Daniels, Nathan, 11
Dauphin Island, 8
de Sauvolle, M., 2, 3, 4
de Soto, Hernando, 2
Deason, John, 10
Deer Island, 10
d'Iberville, Pierre Le Moyne, 1, 2, 3, 170
Dong, Phan Duc, 21
Dukate, William, 16
Dunbar, George, 16
Dunn, Felix, 20
Dupree, Sterling, 6

E

Elmer, F. William, 16
Emmons, George, 10
English Turn, 4
Evers, Medgar, 20

F
Favre, Brett Lorenzo, 41
Fewell, James, 10
Fishbone Alley, 81
Flirt of Biloxi (sailboat), 8
Fort Massachusetts, 78
Fort Maurepas, 2, 4
Fort Sumter, 9
Friendship Oak, 63

G
Galvez, Bernardo, 5
Gorenflo, William, 16
Grant, John, 8
Grant, Ulysses Simpson, 12
Great Migration, 6, 7
Gregory, Larry, 22
Ground Zero Museum, 28
Gulf and Ship Island Railroad, 14, 15
Gulf Islands National Seashore, 133
Gulfport, Mississippi, xi, xii, xiii, xiv, 13, 14, 15, 16, 19, 20, 23, 81

H
Haise, Fred, 20, 21, 38
Hall, Basil, 6
Handsboro Democrat, 13
Handsboro Minute Men, 9
Hardy, William Harris, 14, 15
Henry, R. H., 14
Hine, Lewis, 16
Houston, Sam, 12
Hurricane Hunters, 20
Hurricanes: Betsy, xiii, 22; Camille, xiii, xiv, 22, 28, 91, 113; Elena, 9, 21, 22; Georges, 9, 21, 22; Isaac, 9; Katrina, xi, xii, xiv, 8, 13, 22, 23, 28, 36, 96, 102

I
Infinity Science Center, 21, 38
Ingalls Shipbuilding, 143
Island View Casino, 76

J
Jackson, Andrew, 7
Jackson Clarion Ledger, 14
Jackson Daily News, 20

Jefferson, Thomas, 5
John C. Stennis Space Center, 20, 21, 38
Johnson, Andrew, 12
Johnston, Joseph Eggleston, 12
Jones, Ap Catesby, 7
Jones, Joseph T., 15

K
Keesler, Samuel Reeves, 19
Kiln, Mississippi, 41
Koerner, John, 17

L
La Salle, Rene-Robert Cavelier, Sieur de, 2, 4
Lee, Robert Edward, 12
Lincoln, Abraham, 9
Long Beach, Mississippi, xiii, xiv, 8, 14
Longfellow, Henry Wadsworth, 19, 148
Lopez, Lazaro, 16
Louisiana Purchase, 6
Lynn Meadows Discovery Center, 69

M
Madison, James, 6, 7
Mardi Gras, 9, 18, 19, 109, 160
Marin (vessel), 3, 4
Mary Mahoney's French House, 110
Mason, Gilbert, 20
Maycock, John, 16
Mayfield, Mendy, 21
Mexican War, 8
Meyer, Joseph R., 17
MGM Park, 94, 115
Miller, Marlin, 38
Mississippi Aquarium, 23
Mississippi Territory, 5, 6, 7
Mobile, Alabama, xi, 2, 4, 5, 6, 7, 8, 9, 11, 13, 18
Monroe, James, 7
Montgomery, R. H., 8
Moreell, Ben, 19
Mount Pleasant United Methodist Church, 13

N
New Orleans, Louisiana, 2, 4, 5, 7, 8, 9, 10, 11, 13, 14, 16, 17, 18, 20
New Orleans Daily Delta, 8

New Orleans Daily Picayune, 8
Nixon, George, 7

O
Ocean Springs, Mississippi, 7, 12, 13, 18, 22, 23, 61, 131, 133, 136, 162
Ocean Springs Community Center Mural, 18, 136
Ohr, George, 17
100 Men Debating Benevolent Association Hall, 36
Oudt, John, 17

P
Pascagoula, Mississippi, xi, xiv, 5, 6, 7, 8, 11, 19
Pascagoula Indians, 1, 2
Pascagoula River, 2, 3, 6, 19, 142, 145
Pass Christian, Mississippi, xiii, xiv, 7, 8, 10, 15, 22
Pass Christian Yacht Club, 8
Patton, George S., Jr., 19
Pearl Harbor, 19
Penicault, Andre Joseph, 4
Pettus, John J., 9
Pitt, William (the Elder), 5
Pollock, Oliver, 6
Pontchartrain, Comte de, 2
Port of Gulfport, 15, 67
Powell, Murella Hebert, 16

R
Reed, Pleasant, 96
Robinson, Jesse, 16
Roosevelt, Franklin D., 19
Round Island Lighthouse, 149

S
Scarlet Pearl Casino, 125
Seafood and Maritime Museum, 88
Second Louisiana Native Guard, 11
Shearwater Pottery, 18, 162
Sherman, William Tecumseh, 12
Shieldsboro, Mississippi, 7, 12
Ship Island, 2, 3, 4, 5, 8, 9, 10, 11, 14, 15, 78
Six Sisters, 7, 8
Smith, James A., 14
Smith, Melancton, 10
St. Augustine Seminary, 34, 35

St. Rose de Lima Catholic Church, 31
Strong, George, 10

T
Taylor, Zachary, 8
Tchoutacabouffa River, 18
Tonti, Henri De, 4
Trethewey, Natasha, 11
Triplett-Day Drugs, 74
Trojan (vessel), 15
Turkey Creek, 12, 13
Twiggs, David, 10

U
University of Southern Mississippi Gulf Park campus, xi, 61
USS *Jackson*, 10, 11
USS *Massachusetts*, 10

V
Vietnam Veterans Memorial, 131

W
Waddell, James, 12
War of 1812, 6, 7
Watie, Stand, 12

Y
Yates, A. R., 12

OCT 24 2018

HEWLETT-WOODMERE PUBLIC LIBRARY
3 1327 00662 0702

14

28 Day Loan

Hewlett-Woodmere Public Library
Hewlett, New York 11557

Business Phone 516-374-1967
Recorded Announcements 516-374-1667
Website www.hwpl.org